LISE HERZOG

JUST FOR FUN:
DRAWING

More than **100** fun and
simple step-by-step projects for
learning the art of basic drawing

table of contents

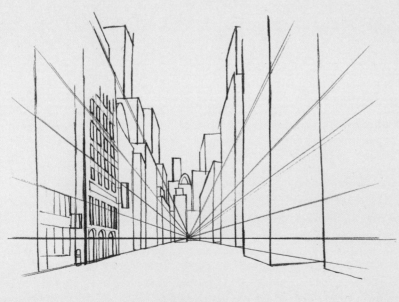

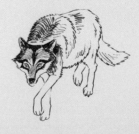

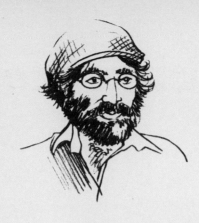

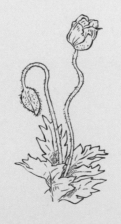

foreword

You've always dreamed of learning how to draw. You're in awe of people who know how to draw because they make it seem like magic. But there's no magic to drawing. All it really takes is patience, a desire to learn, and a whole lot of dedication.

Drawing is exercise for your eyes. You've picked up this book because you want to learn how to draw, but I'm going to teach you how to see. Because if you see properly, and if you ask yourself the right questions, drawing is a lot easier.

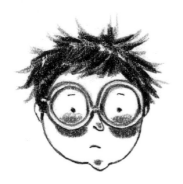

When I was a child, I used to draw characters. I'd draw a face and think to myself, "Now it's perfect—it's really realistic." Then I'd draw it again later and start to doubt myself. I'd find another way to draw my character's face and I'd think, "Now it is perfect—it's really realistic."

No one ever creates the perfect drawing, but that's OK. You can feel happy about your drawing at the stage that you're in and with the skills that you have. Then as you learn more, your skills will sharpen a little more. Along the way, you might sometimes feel disappointed and frustrated. You might have to battle with your pencil or your vision. Just remember: Each drawing is a new step forward. Your last drawing feeds your next.

Don't expect your drawing to be beautiful and complete right away. Go with the flow. A drawing can be beautiful for any number of reasons.

Don't throw away your drawings or tear them apart when you're not happy with them. Give it time! Somewhere down the line, you will find interesting

things about your drawings that will help you progress. If not, you can always look at them and see how far you've come.

We each have our own style, our own way of drawing differently than someone else. Whenever you draw, or try things out, or experiment, you move one step closer to finding your own style.

This phase of discovery also means copying drawings—or styles, manners, and techniques—that you like. The best advice I can give you is: Look closely! Looking closely means noticing details and asking yourself questions. What size is this element compared to that one? What shape is it? Where does it sit in the image? Where is the eye in comparison to the nose or the curve of the cheek? Looking closely also means sensing an atmosphere, finding the story behind a scene, or conveying feelings with soft or hard pencil strokes.

And some days, you will experience the wonderful moment when you look at a drawing and it comes to life right before your eyes.

Pra du ponte Rielo

There are numerous drawing materials and tools available. With time, you'll find the best ones for you depending on the projects you're working on. Then you'll discover that everything around you is made up of the same basic shapes. These shapes are the framework for building more complex objects.

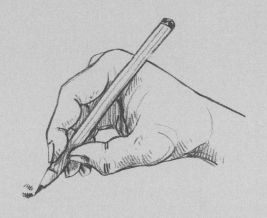

How to Draw & What Tools to Use

MATERIALS

It can feel daunting to draw on "nice" paper. That's why it's better to begin with a simple piece of paper. For your first sketches, paper from a paper ream is perfect. Place a piece of cardboard on your lap or put it against the corner of a table and place your paper on it. You can also use a bulldog clip to hold your paper in place, if that feels more comfortable.

Another option is a sketchbook. A sketchbook has the added benefit of helping you keep a record of your progress. If the paper in your sketchbook is thin, only draw on one side so your sketches don't show through.

Paper comes in a variety of grain thicknesses. Thicker-grain paper allows you to use relatively wet techniques. Avoid glossy paper.

Paper size depends on personal comfort and preference. A good size to start with is a standard 8½" x 11" paper. If your drawings are small and the blank space on the sheet feels intimidating, swap to a smaller size. Conversely, if you constantly feel like you need more space, choose a bigger paper size.

Feel free to experiment with other types of paper, including kraft paper, colored paper, and cardboard.

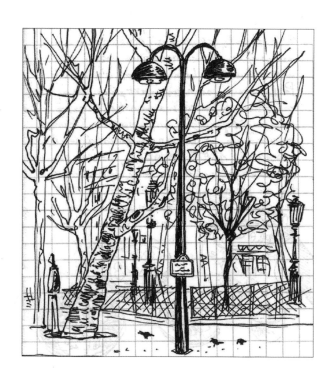

TOOLS

To start, any pencil or ballpoint pen will do the trick. Find something that is comfortable in your hand. You might find that you prefer something darker, thinner, thicker, brighter, or even in a different color. Each tool has different advantages.

Colored pencils come in dry and watercolor varieties.

Quality graphite pencils are the easiest to erase. These come in a variety of densities and thicknesses. The soft ones, such as 2B and 3B, produce a darker result. The hard ones, such as 2H and 3H, create lighter lines.

ERASERS

Erasers are either plastic or kneaded. A plastic eraser is better for working with graphite or colored pencils. A kneaded eraser is indispensable when working with charcoal, but it can be used with other pencils too. To use a kneaded eraser, you swab it instead of rub it.

With both varieties, you need to keep them clean to avoid covering your work with unwanted gray marks. To clean a plastic eraser, rub it on a piece of fabric or scrub it in soapy water. Dry it thoroughly before you use it again.

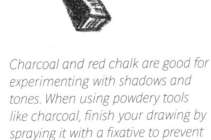

Charcoal and red chalk are good for experimenting with shadows and tones. When using powdery tools like charcoal, finish your drawing by spraying it with a fixative to prevent smudging.

Clean a kneaded eraser by kneading it. Eventually it'll absorb all the graphite that it can handle, and then you'll need to replace it.

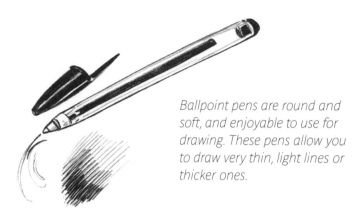

Ballpoint pens are round and soft, and enjoyable to use for drawing. These pens allow you to draw very thin, light lines or thicker ones.

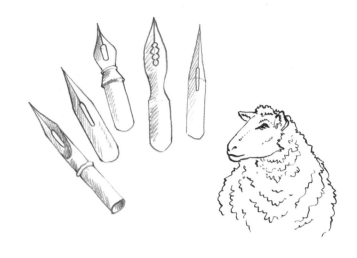

India ink, used with a dip pen or nib pen, creates lively lines as the tip scratches the surface of the paper. Nibs specifically designed for drawing are available, but a simple fountain pen nib will work. You can dilute the ink to achieve different shades of gray, or you can use different colored inks. Be careful of unexpected ink drops!

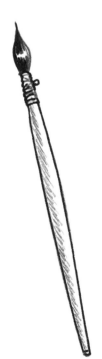

Felt-tip pens come in all shapes as sizes—some with extremely thin tips, and some that are soft like a paintbrush. All of them are interesting tools to work with. Experiment to find the ones that best fit your hand movements.

Drawing with a paintbrush allows you to create soft strokes that can add interest to your artwork.

SETTING UP

In order to draw, you need to set up a space conducive to drawing. You will need enough light and a relaxed atmosphere. If you feel tension in your arm, back, or neck, adjust your position and move around a little. Maybe your setup is wrong or you're tensing up with focus. Remember to breathe and stretch!

If you draw indoors and you're right-handed, make sure the light is coming from your left so your hand doesn't cast a shadow. If you're left-handed, the light should be coming from the right. When you're outdoors, wait until the last minute to do your shading because the light changes so quickly.

Lastly, you'll hold your pen differently depending on whether you're sketching or drawing details.

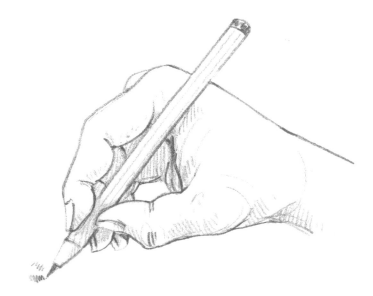

To draw with more precision, hold the pen closer to the tip.

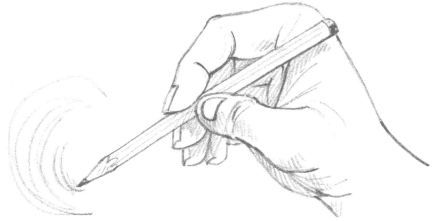

When sketching, place your fingers farther away from the pen tip.

THE BASIC SHAPES METHOD

At first glance, any subject (an object, an animal, etc.) can seem complex. However, everything is just a collection of basic shapes. Look at your subject closely and try to identify its basic shapes. When you begin with shapes, you add stability to your drawing. Shapes are the framework that let you create more complex structures.

There are three basic shapes:

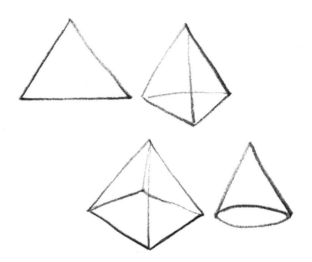

The triangle, which you can turn into a pyramid or cone.

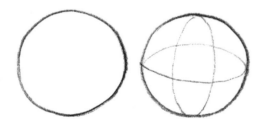

The circle, which you can turn into a sphere.

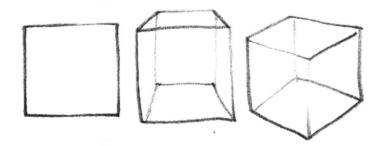

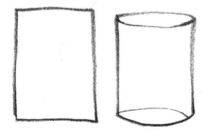

The square, which you can turn into a cube. A rectangle is just a stretched square.

We'll also include an oval, potato-like shape, with weight on the sides that can expand and contract in the middle where needed. This shape is ideal for drawing animals because their bodies have few if any angles or straight lines.

14

DRAWING STEPS

Sketching is the first step in drawing. This is when you use soft lines to draw the underlying framework. Grip your pen gently and loosely, and move your hand around the paper freely. Drawing evolves, becomes refined, and then changes direction.

Once you've decided on the general shapes—the building blocks of your drawing—you can refine your work further. Try drawing over the outlines again with a darker stroke, but be careful not to "freeze" your drawing. The first sketches create movement and life. When you draw over these, you add a bit more rigidity to the drawing. At this stage,

Before you finalize your drawing, you can erase some of initial lines if you feel like they are messy or add darkness to areas you want to make lighter. However, don't do it systematically. Start with the lighter lines; you will go over them with more assurance later. Rather than hurting your drawing, light building lines will add life to it.

don't worry about making your lines too precise. That will come later as you finalize your drawing by adding detailed characteristics, tones, shades, and textures.

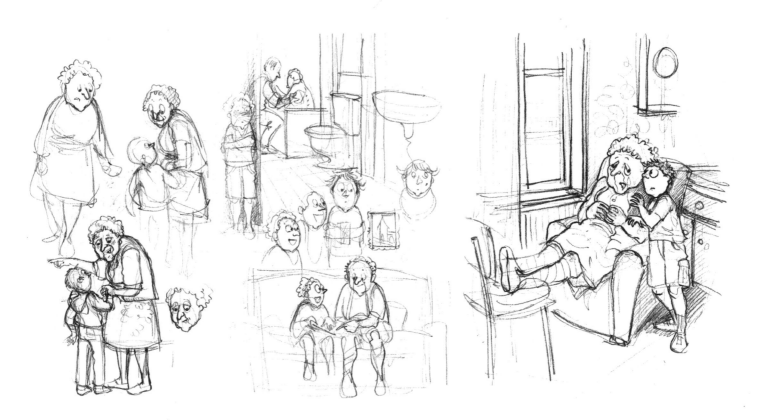

ENHANCING & FINISHING YOUR DRAWING

After sketching, complete your drawing with details and textures. You can begin your drawing with a light pencil and finish it with a thicker, darker one, or just apply more pressure to the pen you used initially. You can also switch to felt-tip or ballpoint pen and erase the pencil before you finalize your drawing. Note that you will need to wait until the felt-tip pen dries before you erase the pencil. If you want to finalize a felt-tip drawing with a moist tool, avoid using a permanent marker to prevent blurring the lines. Ballpoint pen is light and its ink doesn't blur, so it's a good compromise.

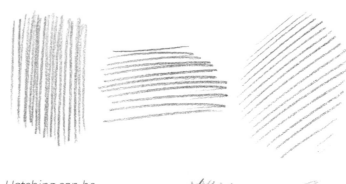

LIGHT & SHADOW

Light gives life and depth to your artwork. Before you begin drawing, decide where the light is coming from. If you struggle to see contrasts, squint your eyes to bring them out.

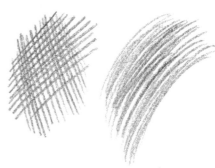

Hatching can be vertical, horizontal, or slanted. It can go all in one direction or intersect. The tighter the lines, the darker the shadow will look.

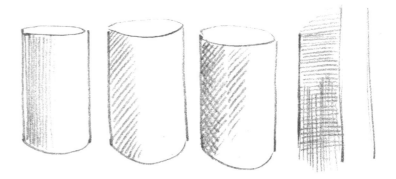

Shadows can appear on the ground, on a nearby surface, or on the subject itself. Create shadows with short lines or hatching. Fill in the shadow until it is as dark as you want it.

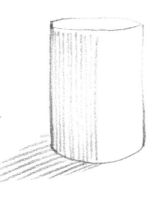

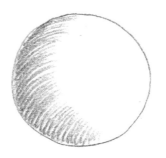

Hatching can also be curved. Curved hatching emphasizes an object's round shape, such as the curves of a vase.

You can achieve a great variety of shades with the same pen. All it takes is to go over the same line a number of times, or apply more or less pressure on the pen. You can also use different types of pens—both soft and hard—in the same drawing.

Add highlights to your drawing with an eraser. For a small area, cut a point out of a plastic eraser and use the tip to remove a specific spot. A kneaded eraser can be used to create different shapes.

You make the drawing your own when you choose a particular drawing style and create a drawing that is comical, sweet, humorous, or poetic. Finish your drawing by creating the whole picture and giving it context. Think about things like setting, background, and sense of place. Enhance your drawing by adding various textures, such as fur, leaves, and patterns.

Drawing an animal means playing with moving shapes and depth. In order to represent the animal accurately, try to identify its character. Observe its habits and postures. By drawing an animal in a typical position, you'll make it easily recognizable and create the impression of catching a fleeting moment. This will make your drawing come to life.

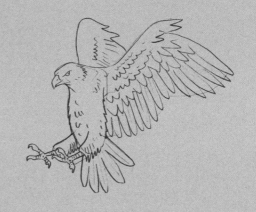

Drawing
Animals

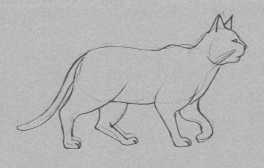

THE CAT

Cats are very flexible. They can curl up or stretch out their entire length. Whatever position they're in, their lower back always looks bigger than their upper back. The more curled up the cat is, the bigger its lower back appears. It helps to imagine that a cat's shape is heavier at the back and tapers toward a small ball for the head.

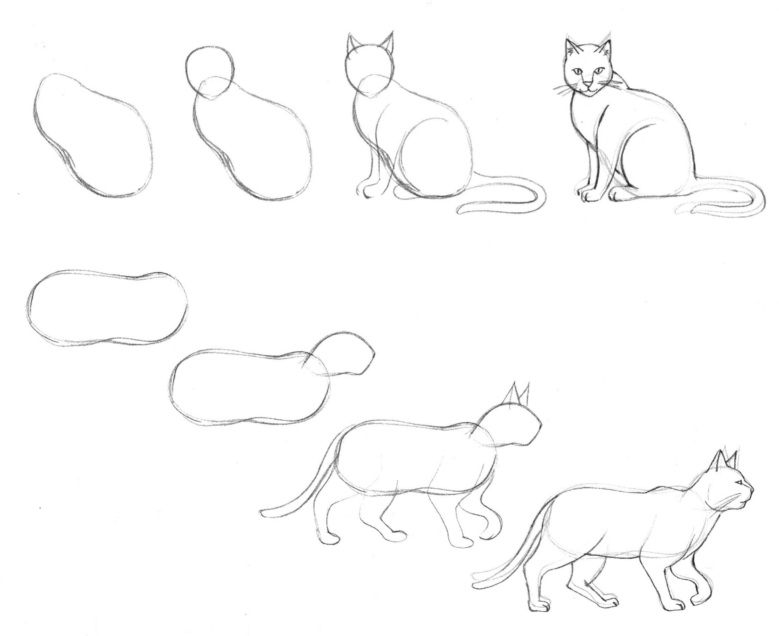

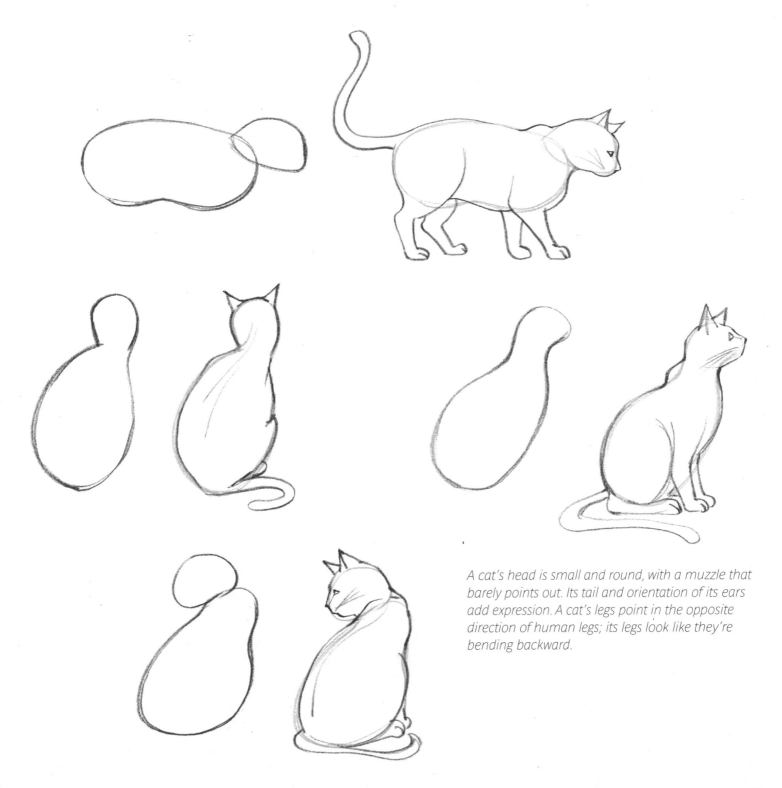

A cat's head is small and round, with a muzzle that barely points out. Its tail and orientation of its ears add expression. A cat's legs point in the opposite direction of human legs; its legs look like they're bending backward.

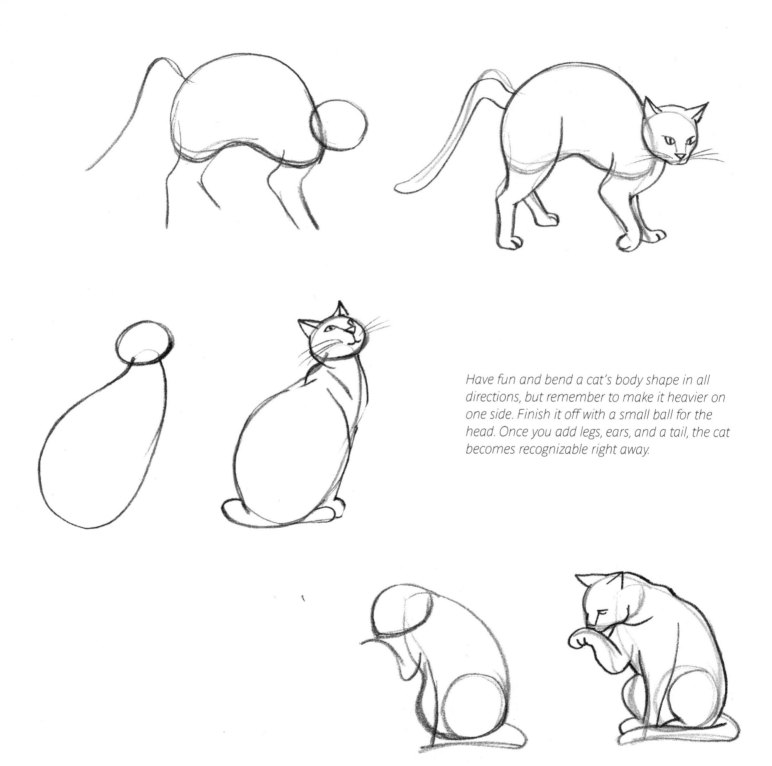

Have fun and bend a cat's body shape in all directions, but remember to make it heavier on one side. Finish it off with a small ball for the head. Once you add legs, ears, and a tail, the cat becomes recognizable right away.

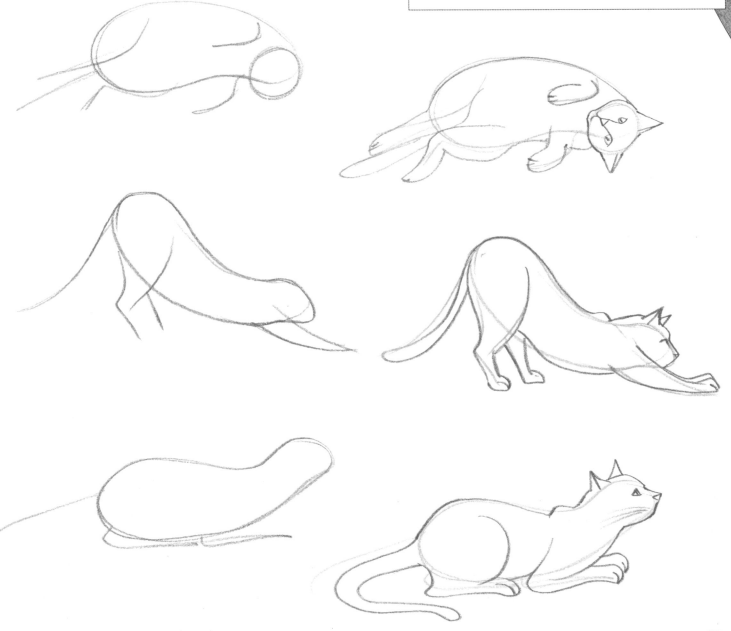

Drawing the hind legs of any mammal can be challenging because they fold and bend backward—the opposite to how human legs work. That joint in the middle of a cat's leg is not a knee; rather, it's the equivalent of a human heel and foot. To use humans as a comparison, you could say that the animal stands on its toes.

BIG CATS

With bigger felines, the body weight moves toward the front, and the muscles develop and become prominent. The legs grow bigger and the muzzle points out a little more. Unique details in the fur, muzzle, and mane display the personality of each animal.

The differences among big cats can be subtle, such as with this panther and jaguar.

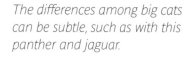

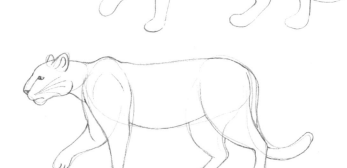

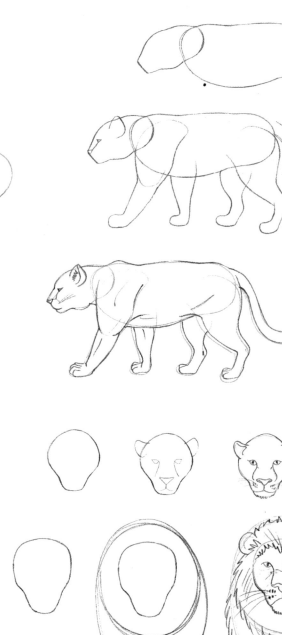

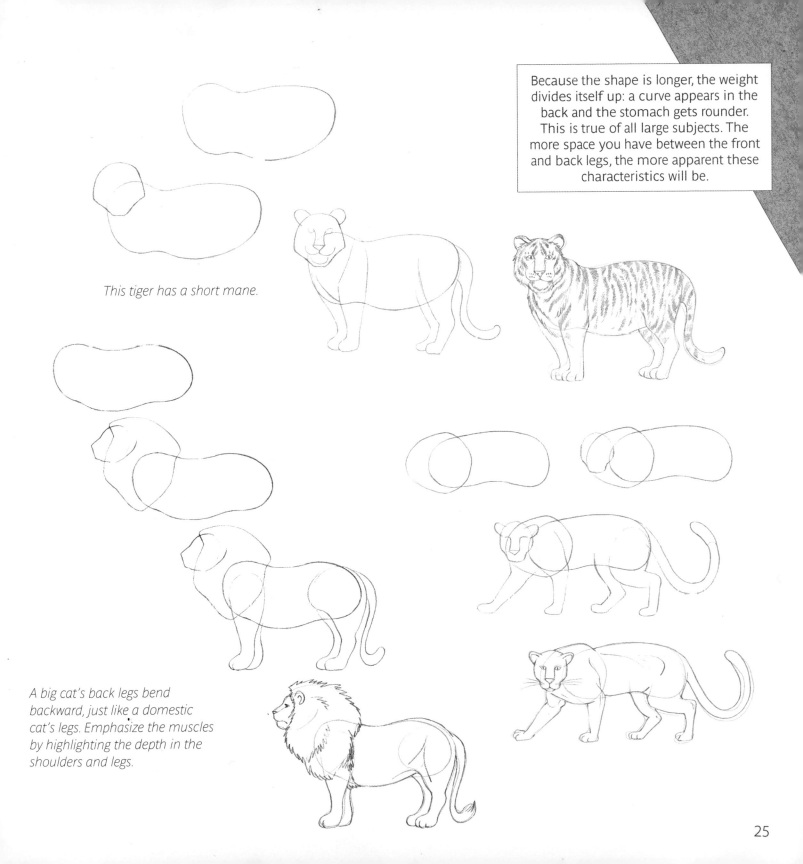

This tiger has a short mane.

Because the shape is longer, the weight divides itself up: a curve appears in the back and the stomach gets rounder. This is true of all large subjects. The more space you have between the front and back legs, the more apparent these characteristics will be.

A big cat's back legs bend backward, just like a domestic cat's legs. Emphasize the muscles by highlighting the depth in the shoulders and legs.

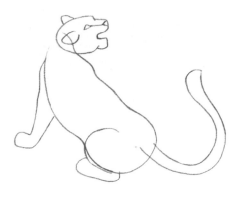

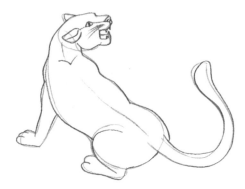

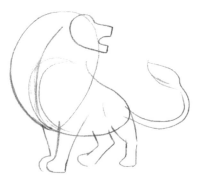

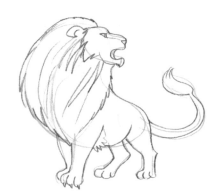

A big cat's body is flexible, similar to a domestic cat's. When curled up, its body is heavier in the lower back; when stretched, it becomes thinner.

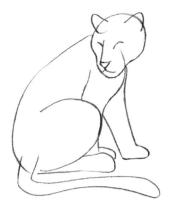

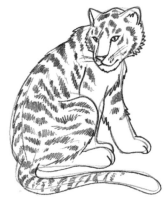

Details, such as coat pattern, make an animal recognizable.

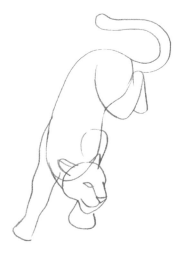

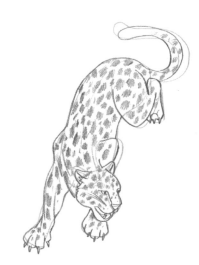

TECHNICAL FOCUS

A paintbrush or other soft tool is especially suited for drawing big cats. A felt-tip pen in the shape of a brush also works well. The tool's flexibility will help you create a svelte and silky subject. Highlight the muscles to emphasize the cat's power.

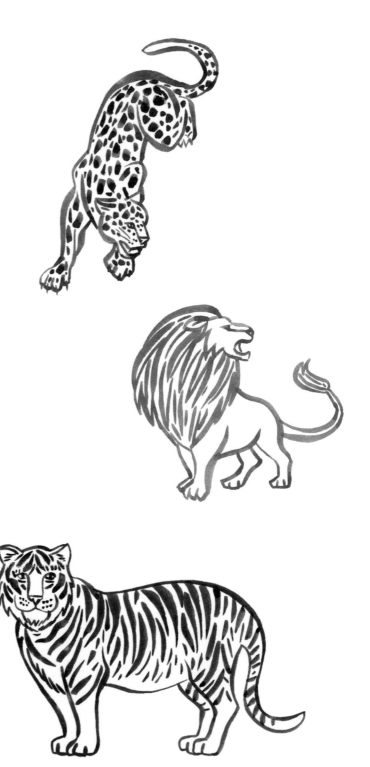

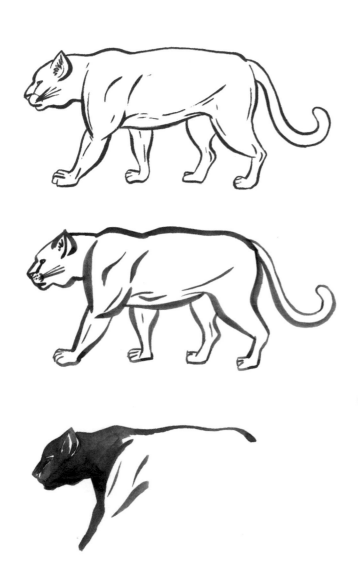

THE DOG

Dogs differ from cats in many ways. For instance, their legs are thinner, their muzzles are usually pointier, and their bodies are a little stiffer and more angular. Details are very important when drawing dogs, including the size and shape of the ears, tail, and muzzle. The fur also varies a lot in length.

It's difficult to generalize dog proportions because there are so many different breeds. However, it's fair to say that the front part of the body is heavier than the back. The muzzle tends to be long and a little square at the front.

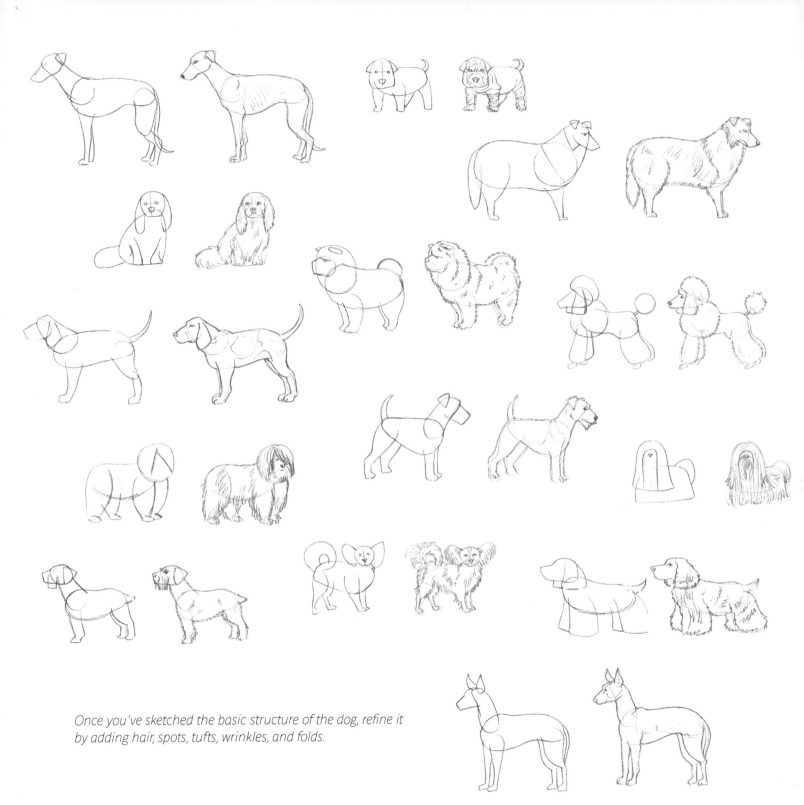

Once you've sketched the basic structure of the dog, refine it by adding hair, spots, tufts, wrinkles, and folds.

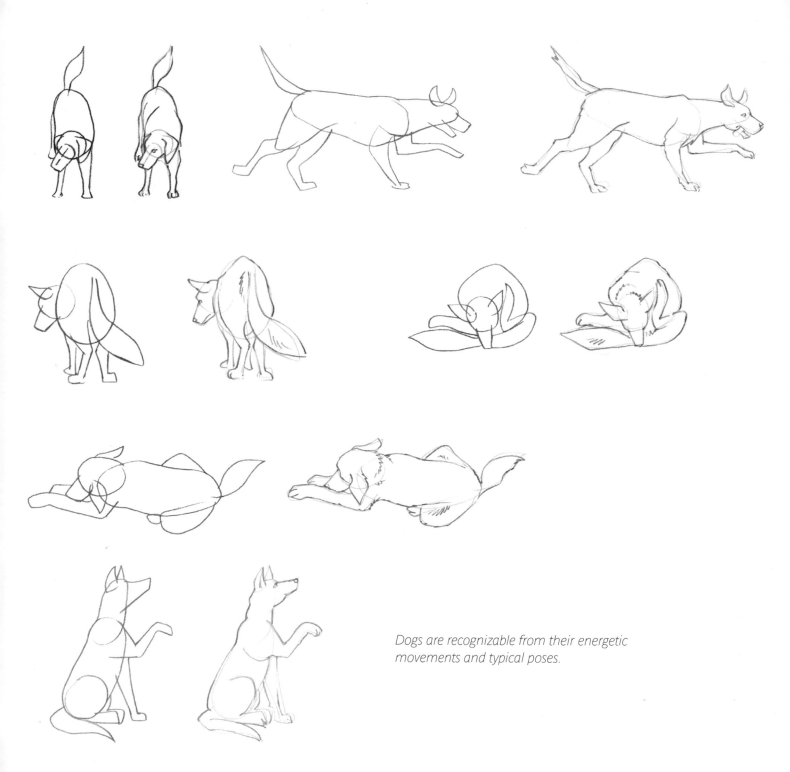

Dogs are recognizable from their energetic movements and typical poses.

TECHNICAL FOCUS

Drawing fur is a great opportunity to try out different pencils and techniques because a dog's fur is quite varied. With long strokes, you can create long, straight, or supple hair. Depending on the nature of the fur—whether it's curly and heavy or light and mobile—the coat follows the dog's movements in different ways.

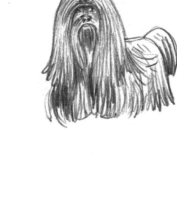

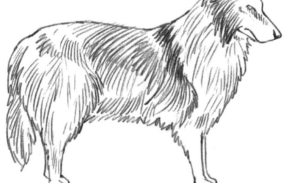

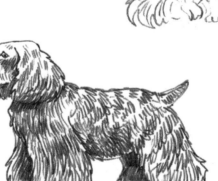

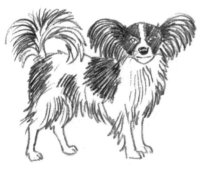

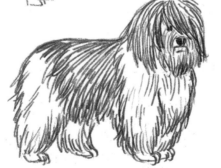

By making certain areas of the coat darker, you create depth and suggest coat color, nuances, and markings.

THE WOLF

A wolf is like a big dog with a thin, long muzzle. His cousin, the German Shepherd Dog, can be a good starting point. A wolf has pronounced hair, which can sometimes be messy, and it's denser at the top of its back, like a mane. Drawing a wolf in a typical pose will make it easier to identify.

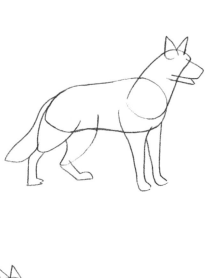

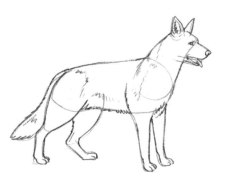

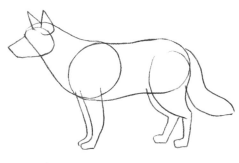

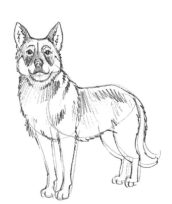

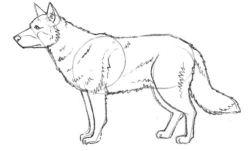

From dog to wolf ...

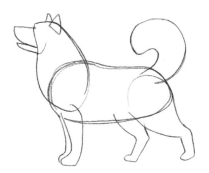

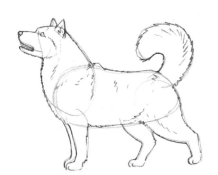

TECHNICAL FOCUS

A wolf's hair is wild and represents the coarse, free nature of the animal. With a pencil, draw the hair by making certain areas denser to give the whole picture depth.

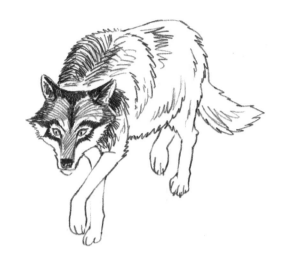

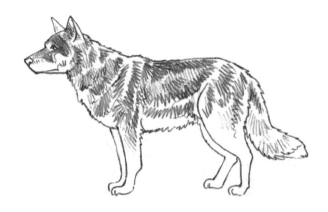

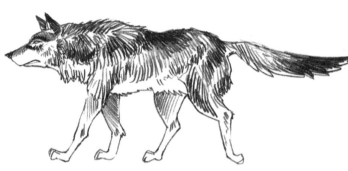

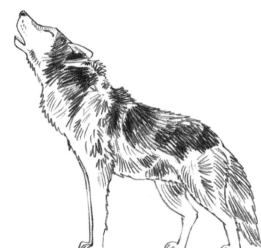

THE FOX

A fox is smaller and more hunched than a wolf. Its muzzle is short and quite wide at the side. Its tail is bushy.

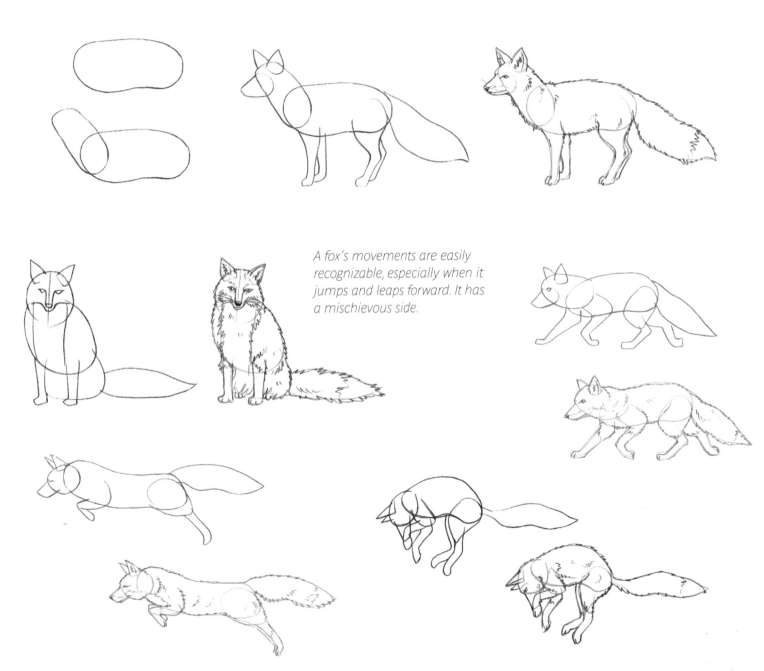

A fox's movements are easily recognizable, especially when it jumps and leaps forward. It has a mischievous side.

THE RABBIT

Like a cat, a rabbit's bodyweight is mainly located at the back. It leaps forward more than it walks, which explains its big hind legs. Its muzzle is like a small, horizontal pear, finished by a Y-shaped nose. Its tail is barely a pompom, and its big ears make it very recognizable. When it is standing up, a rabbit looks like a small pouch topped by a knot with two wide buckles.

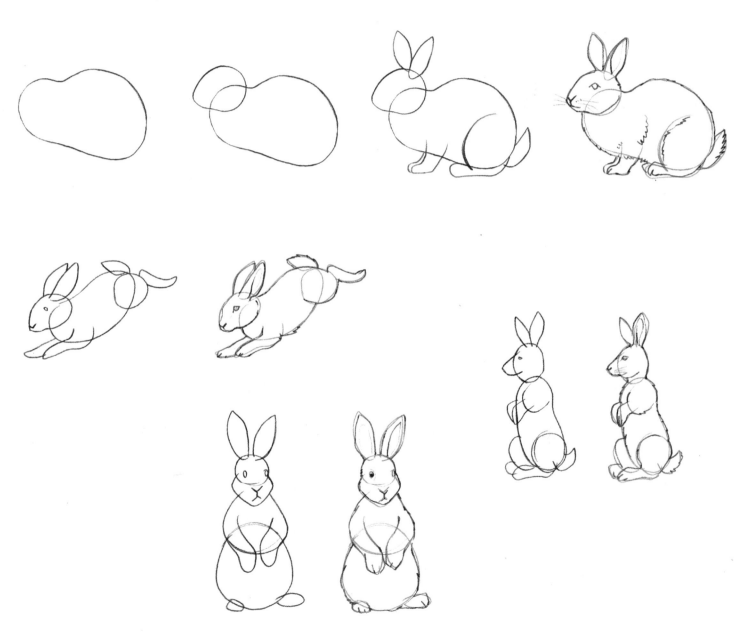

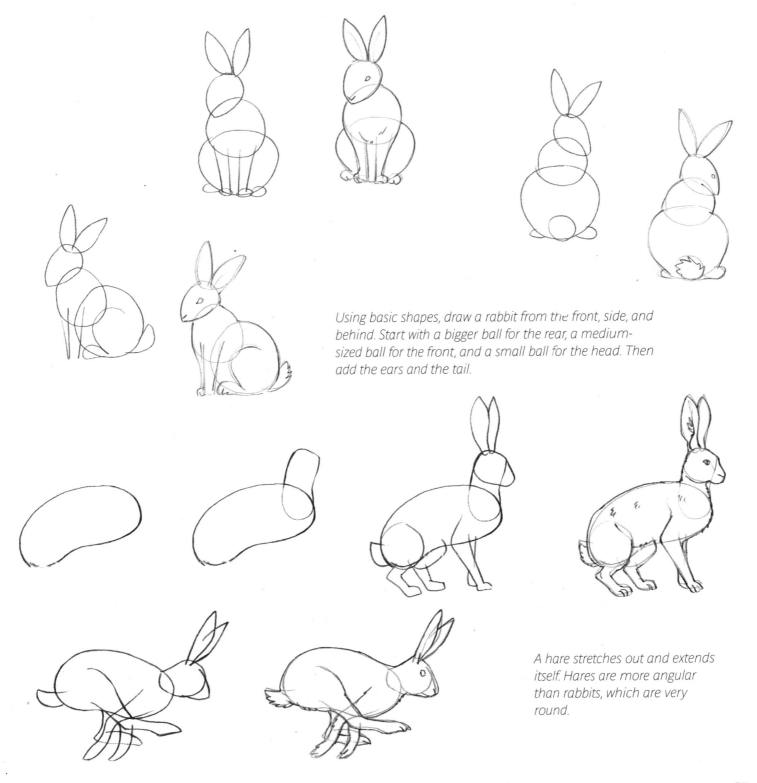

Using basic shapes, draw a rabbit from the front, side, and behind. Start with a bigger ball for the rear, a medium-sized ball for the front, and a small ball for the head. Then add the ears and the tail.

A hare stretches out and extends itself. Hares are more angular than rabbits, which are very round.

THE MOUSE & THE RAT

A mouse has a pointy nose and a long tail. Its muzzle is very pointy and its feet include long claws. It's the ears that make this animal recognizable, as well as its little whiskers. A rat is like a stretched-out mouse with a striped tail.

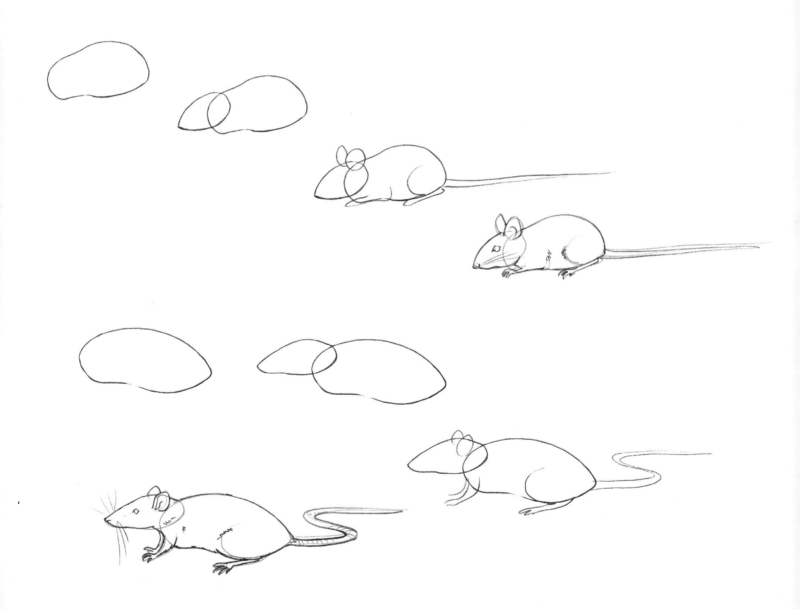

TECHNICAL FOCUS

After you've learned how to draw an animal and know its characteristics, you can take some liberties and transform it by creating a story that shows it in new positions.

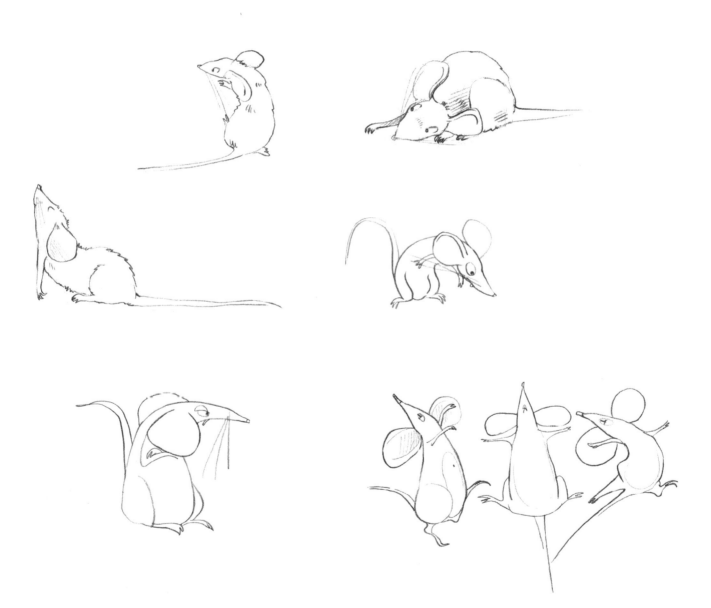

THE SQUIRREL

A squirrel stands out due to its funny behavior and bushy tail. Its ears are covered with tufts of hair. Its claws are very pronounced and look almost like fingers, which are helpful for climbing trees.

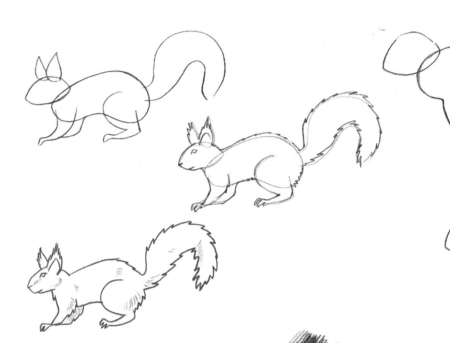

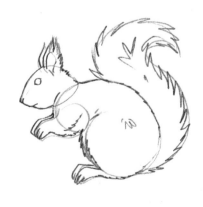

A squirrel's coat calls for color! Colored pencils work great here because you can overlap color easily if you start with the lightest colors and move to the darkest. Choose colors that work well together. Avoid applying the colors too uniformly to prevent flattening your drawing. Use light touches of color to bring out a variety of tones. You can also choose one color for the outline and another for a few patches of hair.

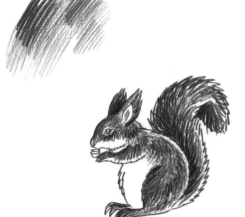

THE HORSE

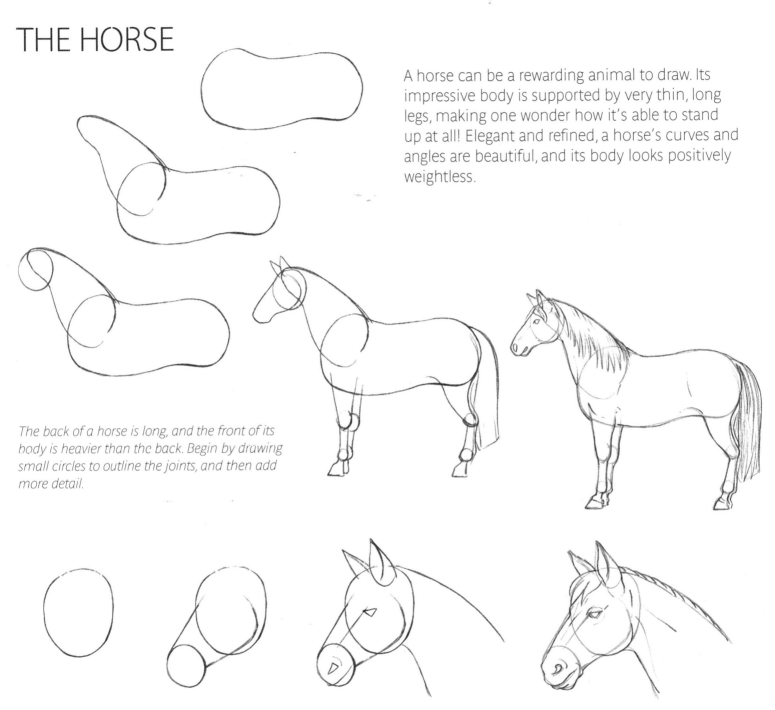

A horse can be a rewarding animal to draw. Its impressive body is supported by very thin, long legs, making one wonder how it's able to stand up at all! Elegant and refined, a horse's curves and angles are beautiful, and its body looks positively weightless.

The back of a horse is long, and the front of its body is heavier than the back. Begin by drawing small circles to outline the joints, and then add more detail.

A horse's neck is long, topped by a small head that extends into a fine muzzle with large nostrils.

To keep its balance, a horse hops around from one leg to the next, alternating front and back, right and left. Most people draw a galloping horse with its legs stretched outward, but this position is impossible for a horse!

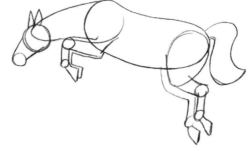

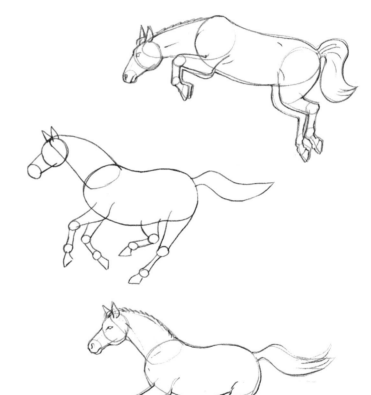

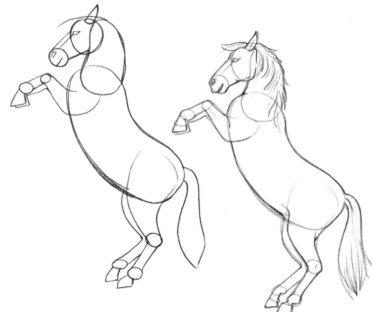

Despite its substantial height and weight, a horse can stand on its back legs, jump over obstacles, and gallop. Look closely and you'll notice that a horse never completely stretches its legs.

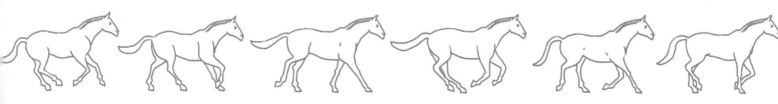

TECHNICAL FOCUS

A fountain pen and india ink are interesting tools to use for drawing. The scratching on the paper from the metal nib can create beautiful, edgy lines.

EQUINE ANIMALS

A foal is a more slender version of a horse.

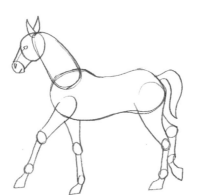

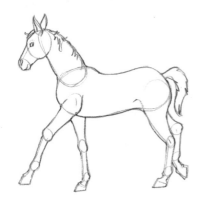

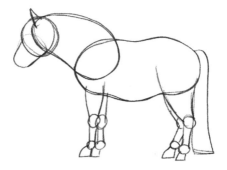

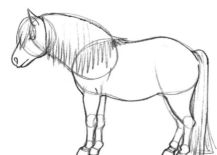

A pony is a bit chubbier and its muzzle is shorter. Its mane can be very long.

A donkey's legs are shorter than those of a horse. A donkey has a stockier build and a larger, rounder muzzle than a horse.

A zebra is slightly smaller than a horse. It is distinctive because of its striped coat. Crayons work well for drawing a zebra's coat because they are thin enough to trace the details of the coat, yet dark enough to fill in the patterns.

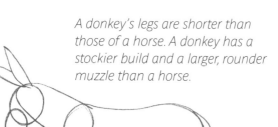

Observe the differences between the tails. One tail is a stream of hair coming out directly at the bottom of the animal's back; the other is long and rigid, with only a tuft of hair at its end.

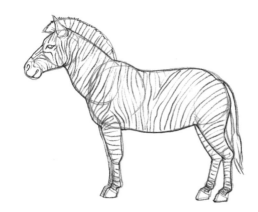

44

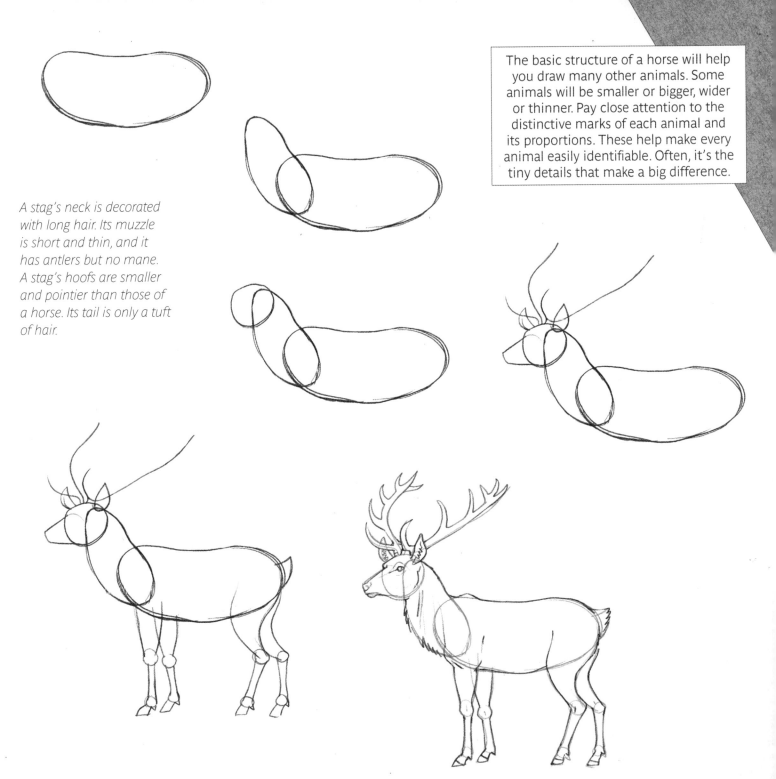

The basic structure of a horse will help you draw many other animals. Some animals will be smaller or bigger, wider or thinner. Pay close attention to the distinctive marks of each animal and its proportions. These help make every animal easily identifiable. Often, it's the tiny details that make a big difference.

A stag's neck is decorated with long hair. Its muzzle is short and thin, and it has antlers but no mane. A stag's hoofs are smaller and pointier than those of a horse. Its tail is only a tuft of hair.

THE GIRAFFE

A giraffe's thin legs and long body seem to defy the laws of gravity. Its twisted, tilted back allows it to reach way up high with its long neck. The neck becomes thinner as it goes up, finally stopping at a small head and thin muzzle. A giraffe has small, round horns and a cropped mane.

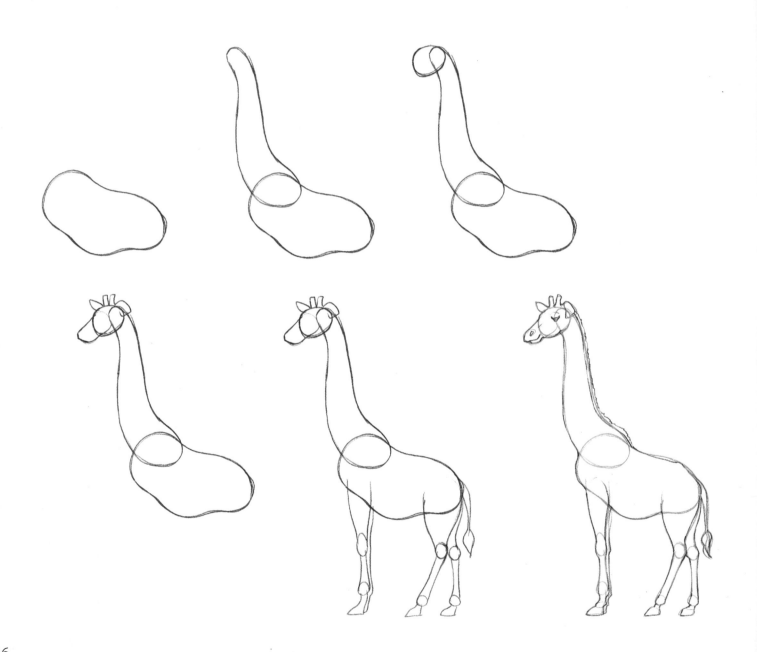

When viewed from the front, a giraffe's head looks strange, as if it is bowing.

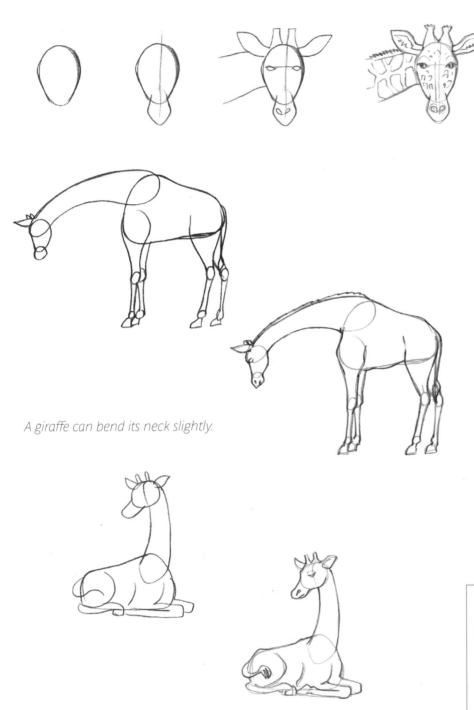

A giraffe can bend its neck slightly.

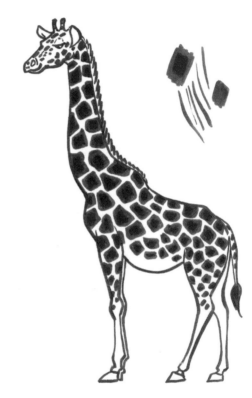

A giraffe's shape is very distinctive, but the animal also stands out because of its coat markings. This is an opportunity to draw with color! I used a felt-tip pen here as though it were a paintbrush. Use slight pressure to draw thin lines; use more pressure to paint in the marks. Go over them again if you want them to look darker.

THE COW

A cow is a big, heavy animal. Its body fits into a rectangle shape; the curves of its belly and back are barely noticeable. Add the neck to one corner of the rectangle, and then draw a circle for the head, a small triangular muzzle, and then a smaller circle. The horns are attached to a small bump on top of its head. Like the horse, the legs include small circles with hooves. A cow's legs are shorter than a horse's legs, and its tail is more rigid and ends with a tuft of hair.

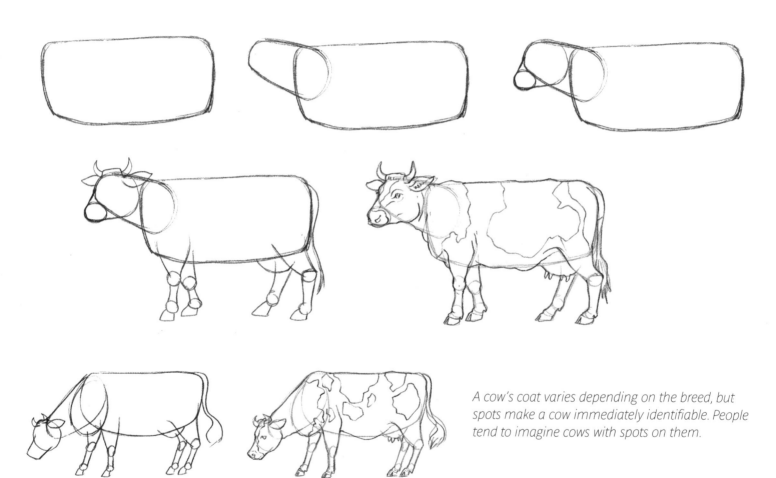

A cow's coat varies depending on the breed, but spots make a cow immediately identifiable. People tend to imagine cows with spots on them.

A cow is heavy and quite stiff in its movements. Use a felt-tip pen with a straight lead to emphasize this rigidity.

THE ELEPHANT

To draw an elephant that's easy to recognize, you only have to draw a big shape, a trunk, a pair of tusks, and big ears. This animal is easy to represent! However, details still matter. When you look closely, you'll notice that an elephant has long legs, a small tail, and triangular head and ears. Be sure to accentuate the folds and wrinkles of its skin.

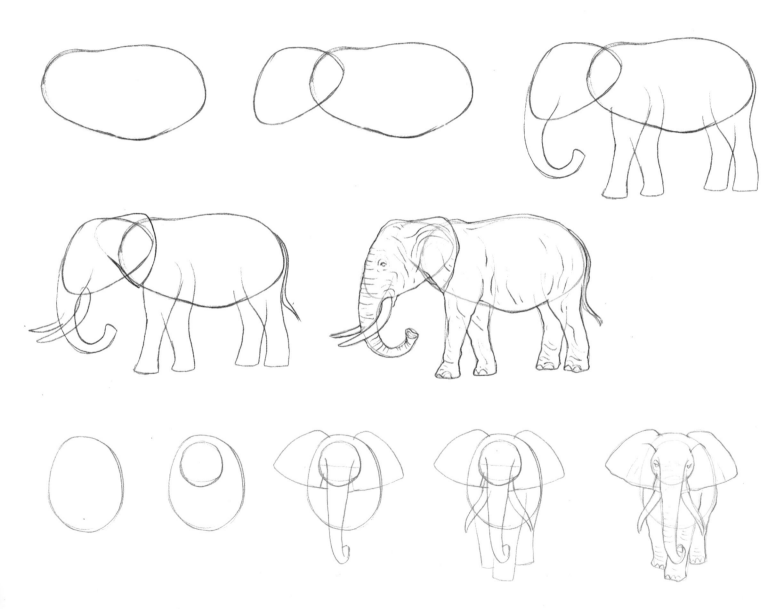

TECHNICAL FOCUS

Charcoal is great for playing with light and shadow, but it doesn't allow for much detail. Use charcoal when you want to cover large areas or make particular areas stand out. You can also accentuate an outline by using the corner of the charcoal stick, or erase part of the charcoal to create highlights.

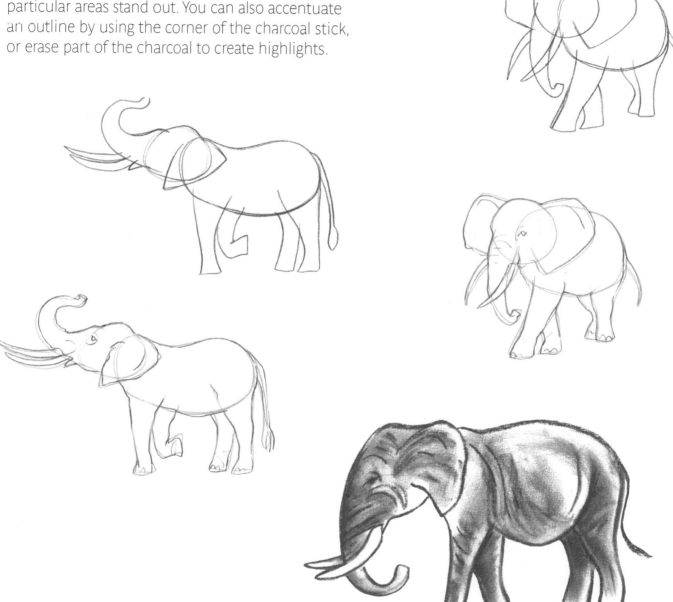

THE BEAR

This animal is as happy standing on four legs as it is on two. It doesn't mind sitting down, either. Its postures are almost human, with a certain clumsiness to them. A bear might look soft, but it's a very powerful animal. Highlighting the width of its legs will demonstrate this power.

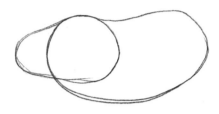

Start with a big, lumpy shape with a curvy back.

Draw a thin neck that starts from the shoulder and highlights the muscles.

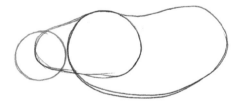

Draw a small circle for the head.

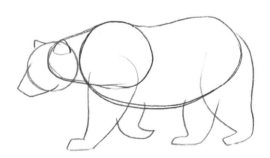

Draw a short muzzle and a small nose. Place small, round ears at the top of the head.

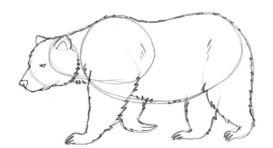

Bears have chubby legs, so there's no need to highlight the joints. Draw paws with long claws, and a minuscule tail.

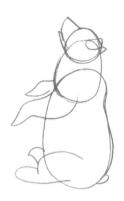
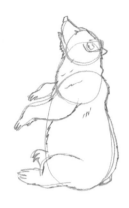

To draw a sitting bear, the principle is the same as a walking one. Make the bear heavier toward the back so it looks settled.

A standing bear looks like a very stocky man. Draw a large peanut-shaped body with a heavy head on top. Include large, stable legs so the bear appears to stand up firm.

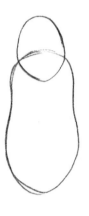
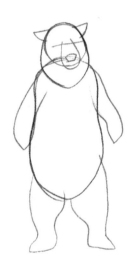
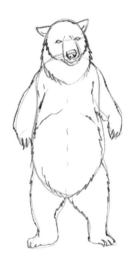

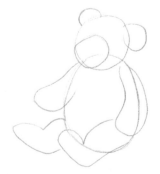
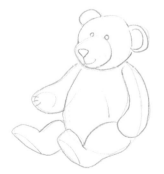

To draw a teddy bear, you have to change the proportions. A teddy bear needs a round shape for the body, small legs, a round head topped with equally round ears—and, of course, a little smile!

THE PANDA

A panda is alluring because it isn't as scary as other bears. Smaller, rounder, and more graceful, a panda always seems to have a smile on its face.

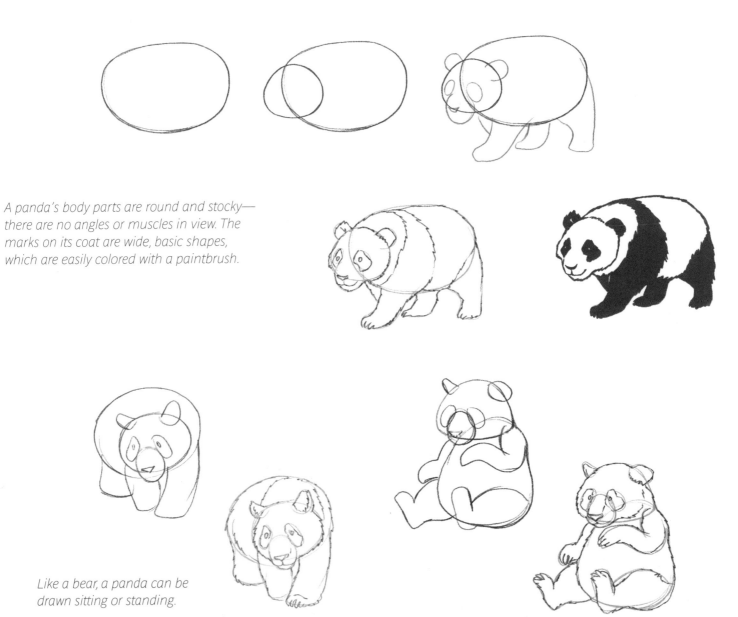

A panda's body parts are round and stocky—there are no angles or muscles in view. The marks on its coat are wide, basic shapes, which are easily colored with a paintbrush.

Like a bear, a panda can be drawn sitting or standing.

BIRDS

When you draw birds, it's important to portray them as light and always ready to fly. There are many different species and varieties of birds, so adding details will bring out their distinctive traits. Look closely at the shape of the bird's beak, the curve of its back and belly, the patterns on its feathers, and the size of its wings.

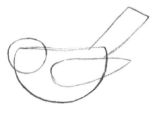 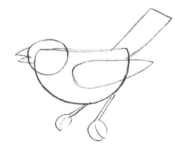 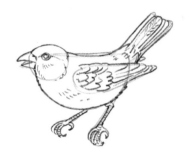

To draw a sparrow, start with a pot-bellied shape with a flat top. Add a small circle for the head. The wings, when folded, start at the shoulders with a round shape that extends in a point. The tail feathers are gathered in a rectangle at the back. The bird is essentially a round shape with straight lines for feathers.

 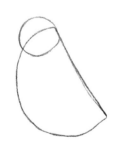 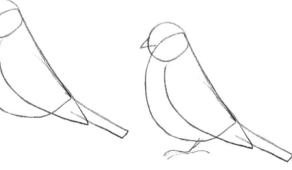 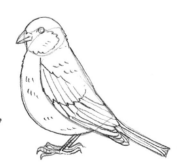

When a bird sits up, its core shape tilts to the side and its back inclines.

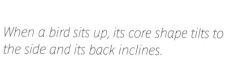

54

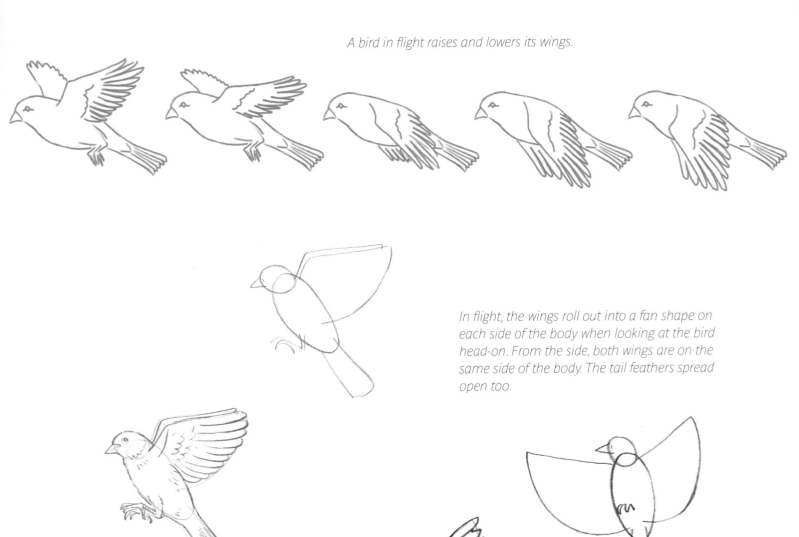

A bird in flight raises and lowers its wings.

In flight, the wings roll out into a fan shape on each side of the body when looking at the bird head-on. From the side, both wings are on the same side of the body. The tail feathers spread open too.

When the bird is bigger, the shapes are bigger and the neck is longer. For this pigeon, the initial shape is the same but elongated.

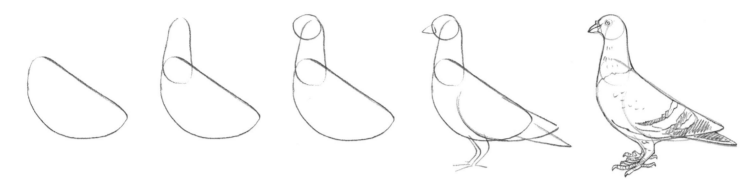

Shapes can tilt and move, as is the case with this dove arching its back and spreading its tail. To draw a dove, include a neck and a small circle for the head.

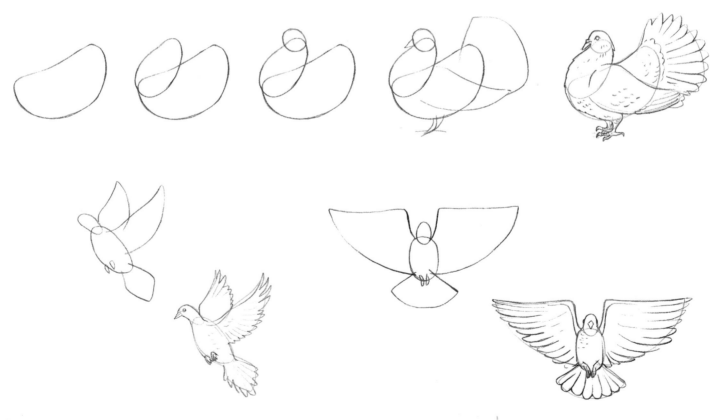

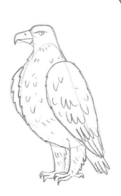

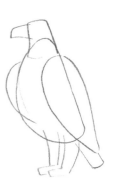

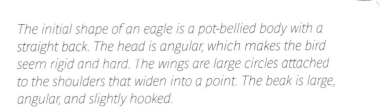

The initial shape of an eagle is a pot-bellied body with a straight back. The head is angular, which makes the bird seem rigid and hard. The wings are large circles attached to the shoulders that widen into a point. The beak is large, angular, and slightly hooked.

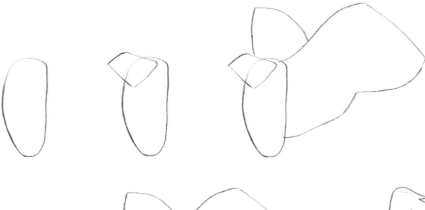

The eagle's open wings and extended tail feathers show details of the bird. The legs are long and end with impressive talons.

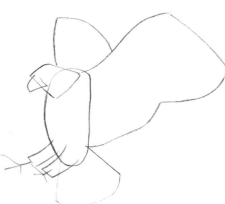

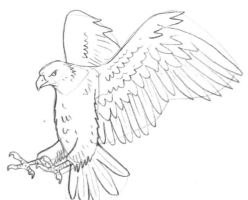

57

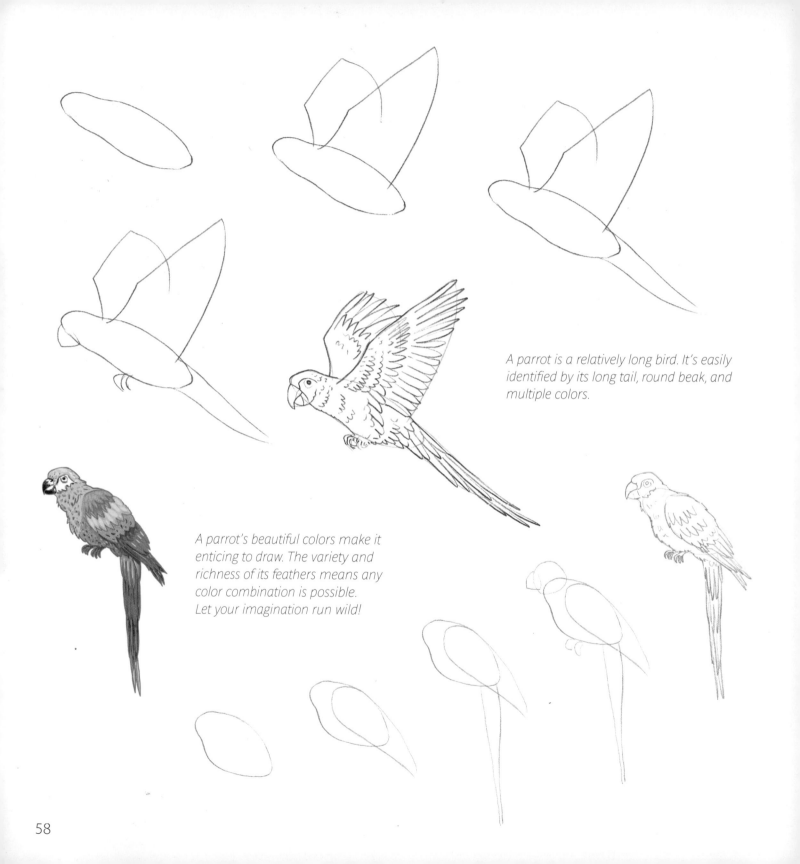

A parrot is a relatively long bird. It's easily identified by its long tail, round beak, and multiple colors.

A parrot's beautiful colors make it enticing to draw. The variety and richness of its feathers means any color combination is possible. Let your imagination run wild!

POULTRY

With all animals, there's a difference between males and females. With chickens, this difference is very obvious: A rooster is tall and complex, whereas a hen is more compact and simple. The initial shape of a rooster is arched; a hen is more round. A rooster's neck is thin and slender; a hen's neck is squat and short. A rooster has many fine, almost extravagant features, whereas a hen is more plain.

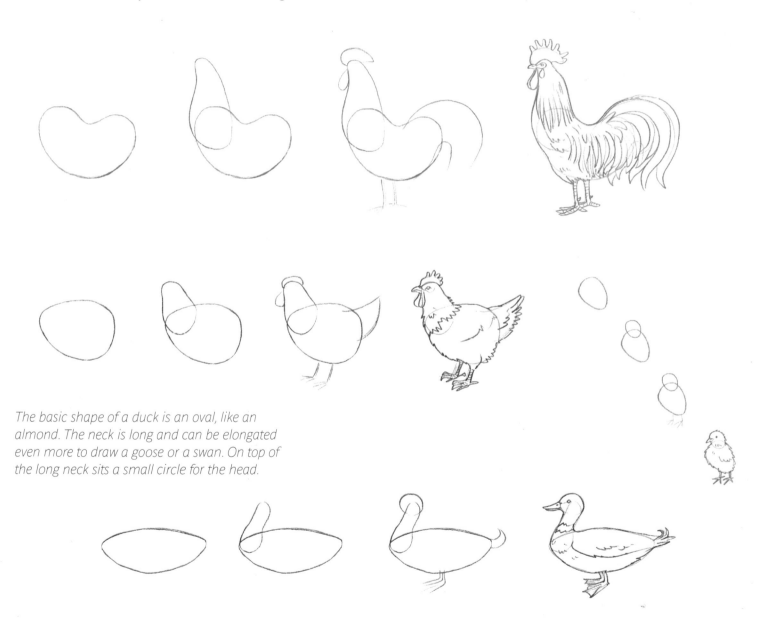

The basic shape of a duck is an oval, like an almond. The neck is long and can be elongated even more to draw a goose or a swan. On top of the long neck sits a small circle for the head.

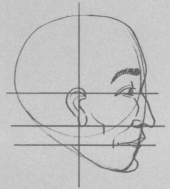

Drawing people is simpler than it seems. When perspective, curves, lines, movement, and attitude all come together, that is when your character comes to life. Don't worry about perfect proportions at first. As you progress, your drawings will become more realistic. Then you can free yourself from reality and reinvent, distort, and change things as you please!

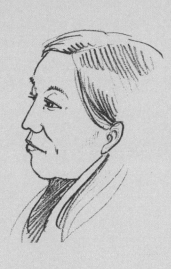

Drawing People

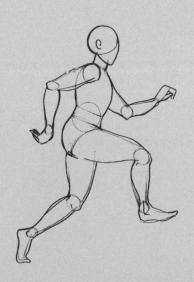

THE PROPORTIONS OF THE BODY

When drawing people, the one and only rule is to look closely. The closer you look, the more you see! Start by looking at your body and comparing one body part with another. What is the size of your head compared to your shoulder width? What is your arm length compared to the rest of your body? Then use these proportions in your work. Remember that even when a drawing isn't completely proportionate, it can still be beautiful, lively, and accomplished.

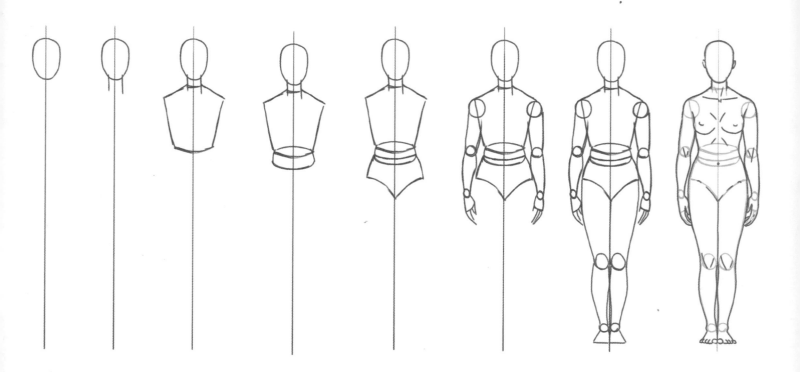

The difference between men and women lies mainly in the width of the shoulders, torso, and hips. You might think that a man is taller and more muscular, and that a woman's body parts are thinner. That isn't always true!

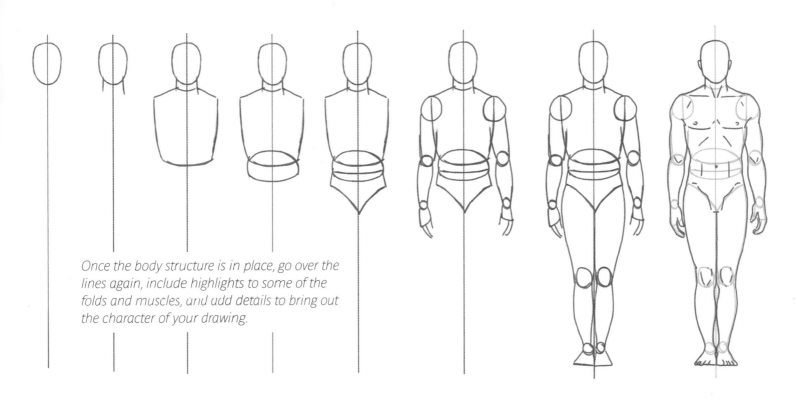

Once the body structure is in place, go over the lines again, include highlights to some of the folds and muscles, and add details to bring out the character of your drawing.

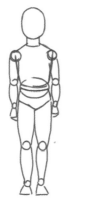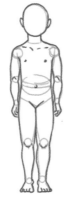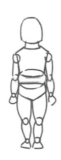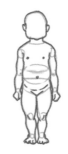

A child's body is still developing—there are far fewer curves, narrower hips, and barely any muscles. Toddler and baby bodies are all curves in a compact form.

These drawing exercises should give you an idea of basic proportions, depths, and motion points. Every step of the drawing builds off the previous step. Each body part is in proportion with another. For instance, the size of the chest is determined by the shoulder's incline—it grows thinner toward the waistline, which curves slightly to suggest a belly. The waistline is an oval shape. Motion points mark the joints. Small circles connect the shoulders to the arms, the arms to elbows and wrists, and the legs to knees and ankles. Muscle depth can be adjusted for each character.

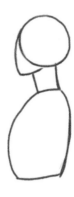
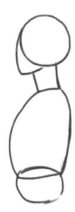

Height-related proportions are the same when viewed from the front or side. What changes is the depth of the silhouette.

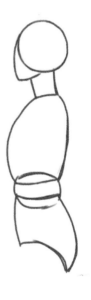
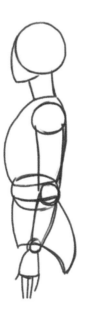
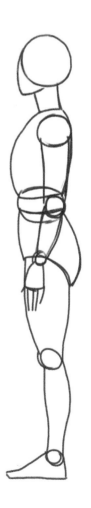
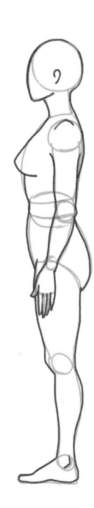

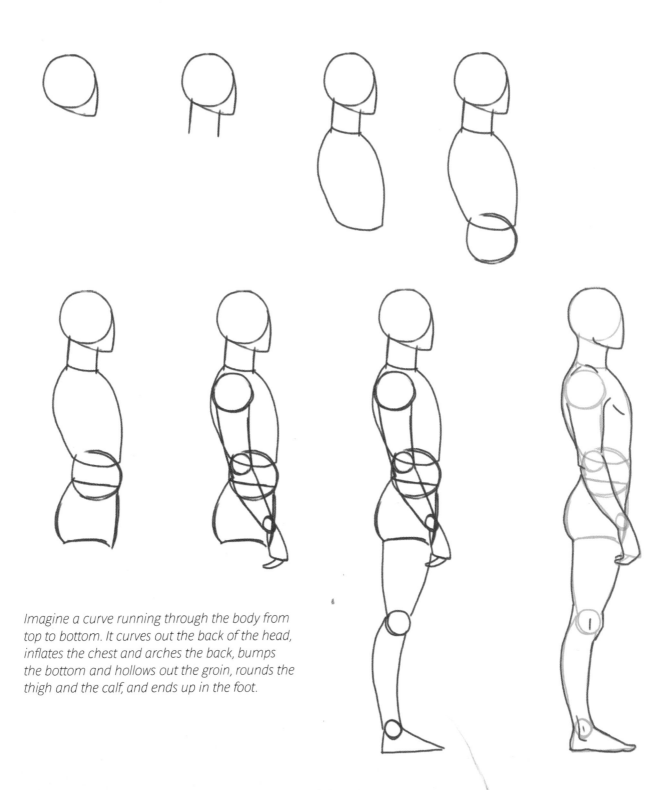

Imagine a curve running through the body from top to bottom. It curves out the back of the head, inflates the chest and arches the back, bumps the bottom and hollows out the groin, rounds the thigh and the calf, and ends up in the foot.

MOVEMENT

Postures help identify your form as male or female
and give life to your character. The body folds at
various points. If you're in doubt of a particular
position, use your own body as a reference.

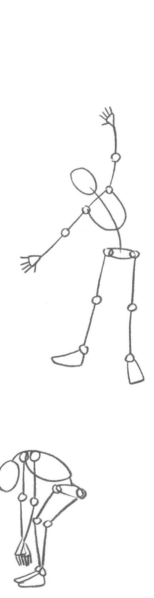

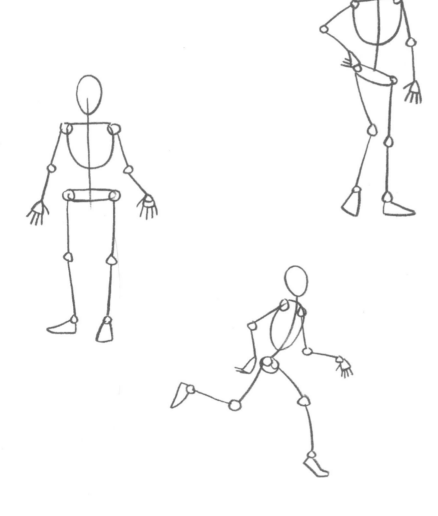

*Stick figures can help you experiment with various
positions and postures.*

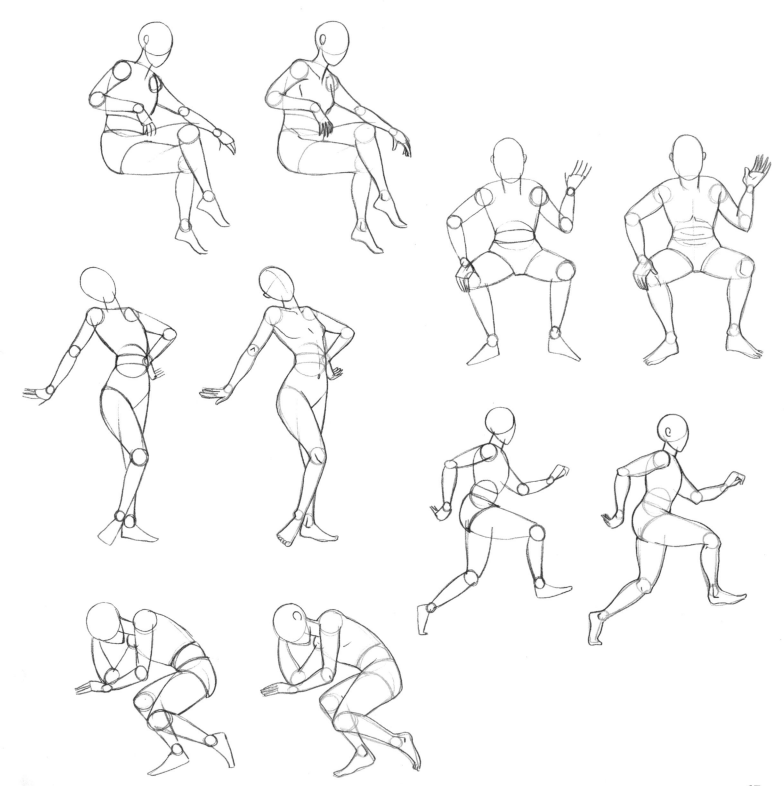

DISTORTIONS

Experiment with body proportions. Exaggerate some body parts or features by making them much larger or smaller. This will help you find the right balance or give you an idea for an imaginary figure.

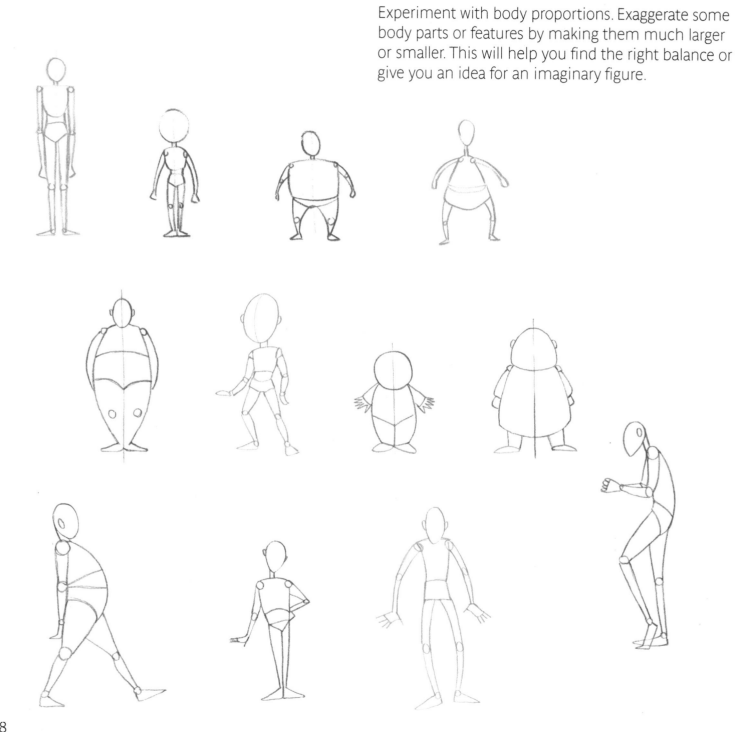

THE HAND

Just like the body, the hand is made of various shapes joined together by motion points. The challenge of drawing a hand lies in balancing the size of each element.

Start with a large, rounded square for the palm.

Draw the wrist, the bottom part of the thumb, and small circles to indicate the bottom parts of the fingers.

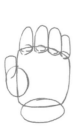 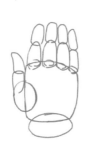 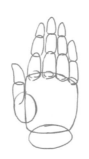 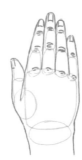

Continue adding the fingers, making sure to include every digit.

To complete your drawing, add small folds to the fingers and include fingernails.

When drawing the inside of a hand, add folds to the palm to create depth.

 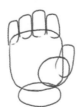 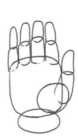 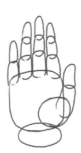 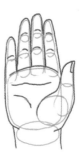

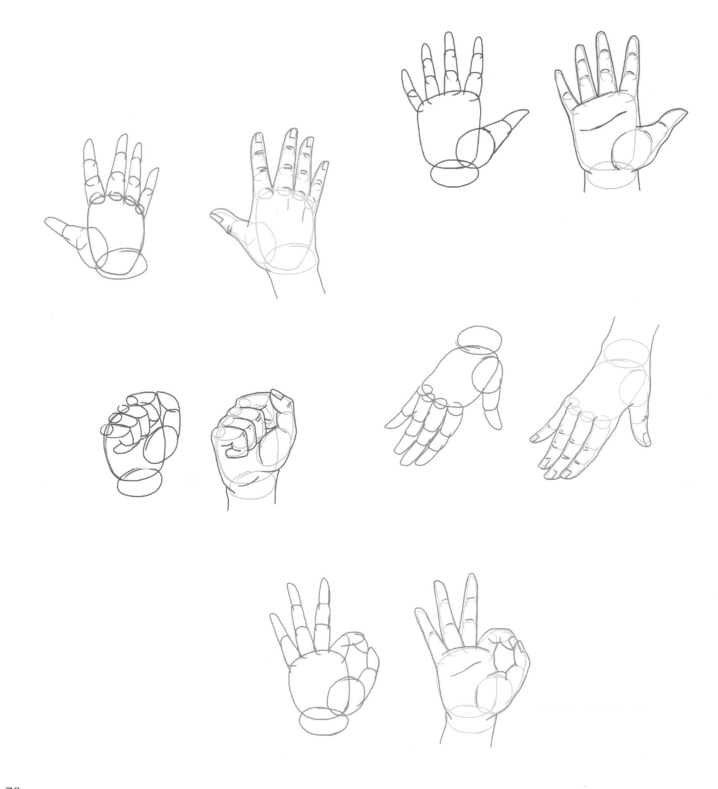

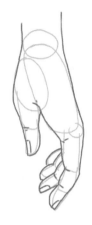

From the side, the hand looks flat. The fingers are behind each other with the thumb below.

An aging character's hand is covered with lines, folds, and wrinkles. You can highlight these details with hatching.

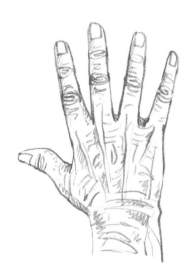

A baby's hand has tiny, slightly pointy fingers attached to a chubby palm.

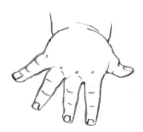

THE FOOT

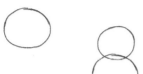

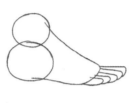

To draw a foot from the side, start with a circle for the heel. Then draw the ankle on top and a triangular shape on the side for the foot. Finish by adding the toes.

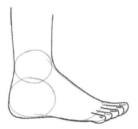

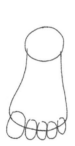

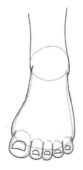

When drawing a foot from the front, the heel isn't visible. Begin your drawing with the ankle. The foot becomes larger closer to the toes, which are lined up largest to smallest.

Standing on tip-toes, the foot remains mainly straight. The folds are between the foot and the toes, and the heel also bends slightly.

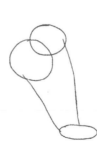

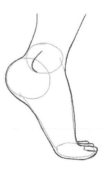

CLOTHING

When drawing clothing, it's very important to show the texture of the fabric. The fabric must fit the body shape closely and crease in the right places. Hatching can help create shadows to hollow out the fabric in certain places, or to highlight the folds, or to suggest that two pieces of fabric are on top of each other.

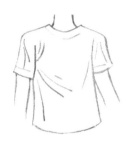 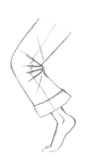 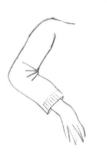

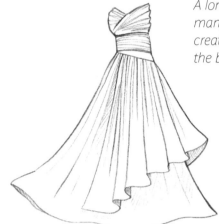

A long dress can have many folds and pleats. This creates a waving effect at the bottom of the fabric.

Generally, clothing creases in the same places that the body creases. Keep in mind the weight of the fabric, which pulls clothes toward the ground.

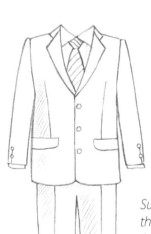

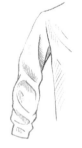

The sleeve of a soft sweater will include lots of rounded lines.

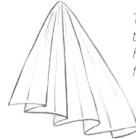

To suggest that a veil is transparent, use a light hand when drawing the folds at the back.

Suits naturally appear stiff until they are bent at the arm or leg. Add a pressed crease down the front of the pants.

The soft curves of this scarf suggest that it's flying in the wind.

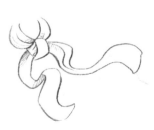

THE FACE

Drawing a face requires following the same rules of proportion as drawing a body. These proportions vary from one person to the next, and they vary even more depending on whether you draw from life or from your imagination. Feel free to play with these rules—or disregard them altogether—to give your drawing a unique style and personality.

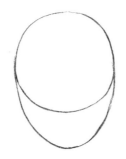

To draw a face from the front, draw a circle and add a curve to the bottom to create an oval shape.

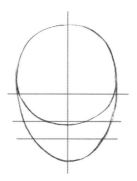

Draw a vertical line down the middle. Then add a horizontal line at the center of the oval shape. Draw a second horizontal line at the bottom of the circle, and a third one at the bottom of the oval.

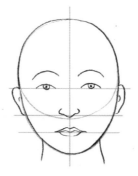

These horizontal lines help position the eyes, the bottom of the nose, and the mouth. The ears fit in between the first two horizontal lines.

 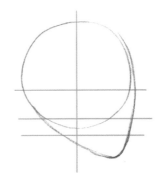 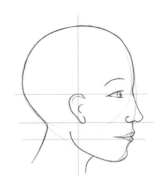

To draw a face in profile, draw a circle to indicate the back of the head. Outline the face starting at the top of the forehead, curving inward for the eye and out again to add the nose, mouth, and chin. Continue the outline up toward the ear. The vertical and horizontal lines are in the same places as in the forward-facing drawing.

 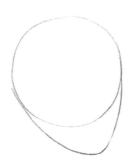 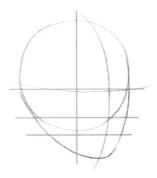 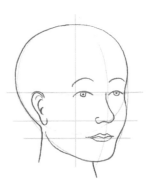

Partially turned away, the tip of the chin is between the center and the side. The facial elements are positioned on a curve.

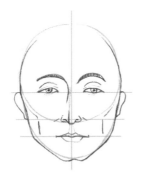 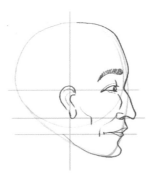

Using this model, you can draw all types of faces. Add a crooked nose, make a pointy chin—use your imagination!

FACIAL EXPRESSIONS

To add expressiveness to a face, look at yourself in the mirror. When you smile, notice where the lines appear on your face. Which parts go up and which come down? With each expression, a face changes. Some areas become rounder, wider, or smaller, and the skin folds here and there. The arrows on the following drawings show the directions in which various parts of the face are moving.

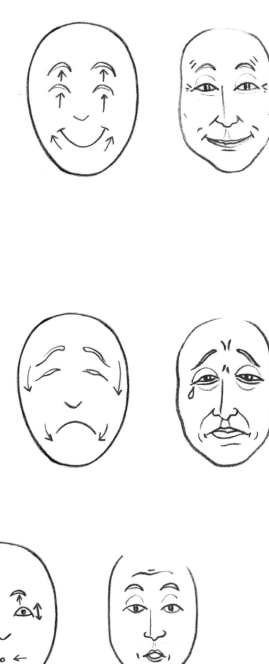

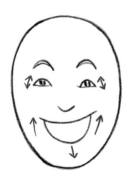
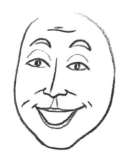

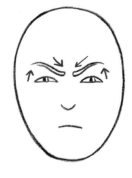
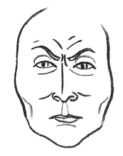

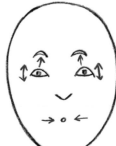
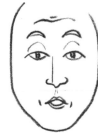

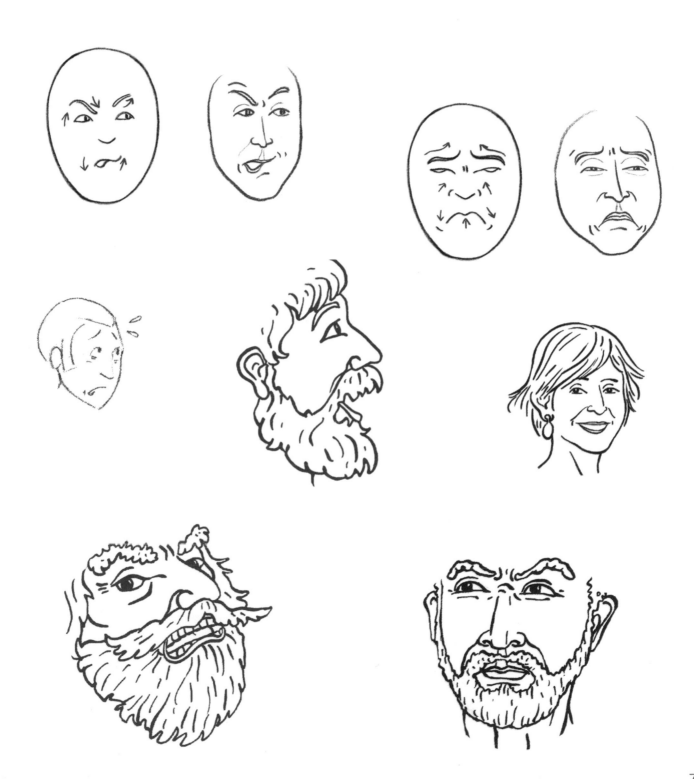

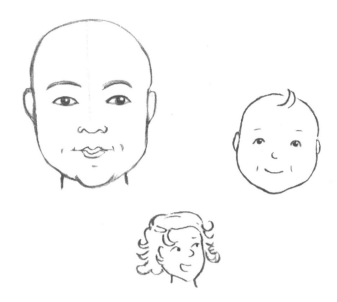

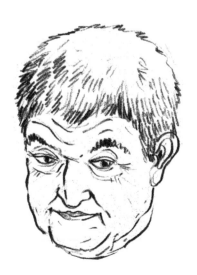

A child's face is round, with a small nose and mouth. Take care when adding lines to a child's face. The more lines you add, the older your character will look.

An aging face drops a little and requires more lines. Features such as the nose, ears, and mouth may change in size and grow bigger or smaller.

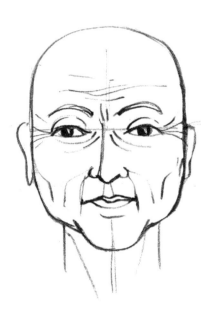

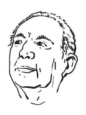

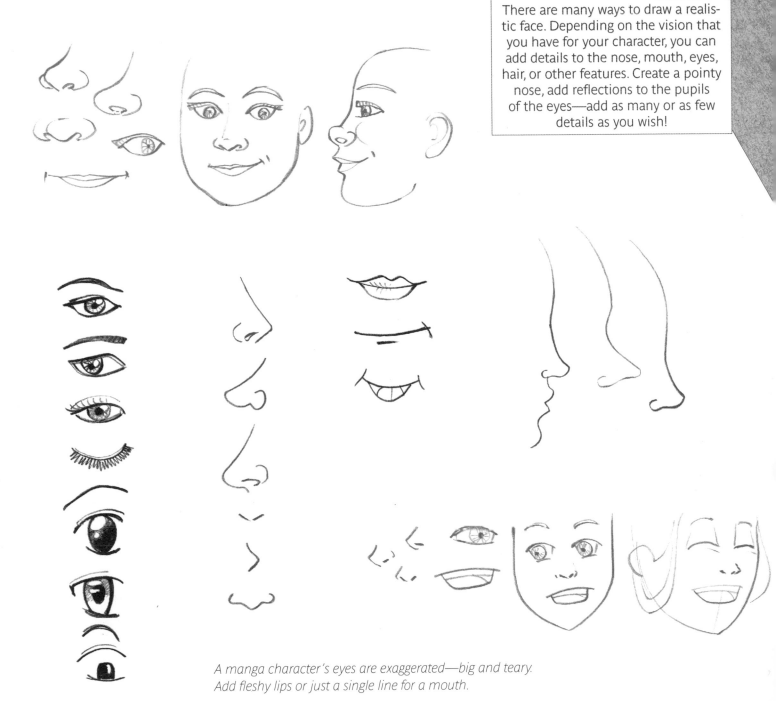

There are many ways to draw a realistic face. Depending on the vision that you have for your character, you can add details to the nose, mouth, eyes, hair, or other features. Create a pointy nose, add reflections to the pupils of the eyes—add as many or as few details as you wish!

A manga character's eyes are exaggerated—big and teary. Add fleshy lips or just a single line for a mouth.

Create different hair textures and styles with different pen and pencil strokes.

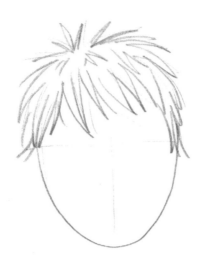

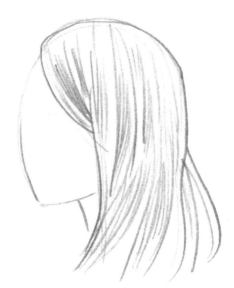

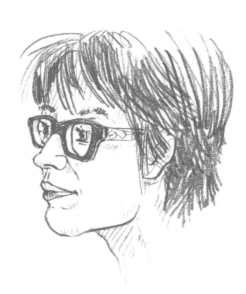

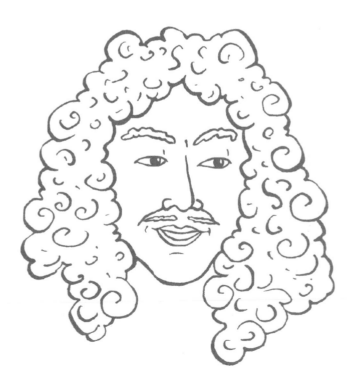

FACES OF THE WORLD

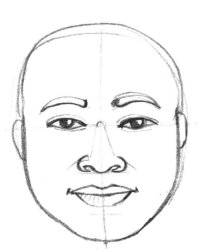

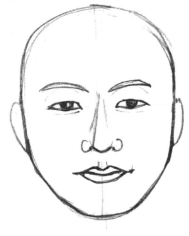

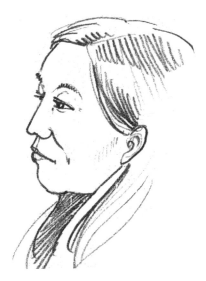

A person's ethnicity can determine their facial features. Look closely at the shape of a person's eyes, nose, mouth, and face.

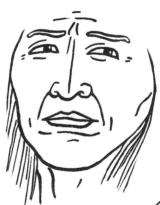

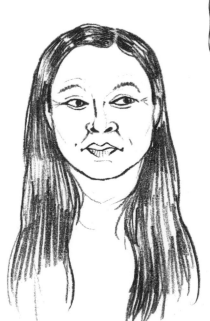

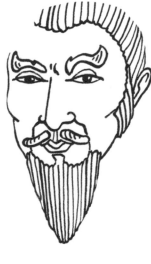

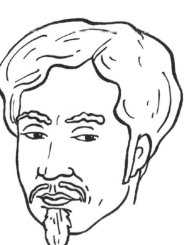

THE SELF-PORTRAIT

To draw a self-portrait, start with a general shape and add the various facial elements, as shown on the next page. Then go over the drawing again to strengthen the lines. You can also start with one element of the face first, and then add the other elements as you go along, as shown below. Always compare the proportions of each element with each other.

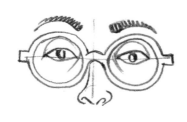

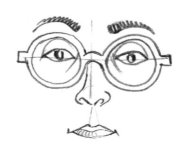

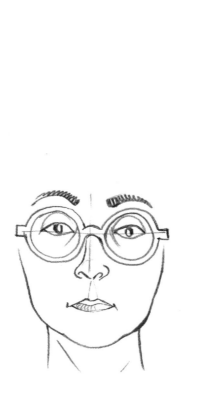

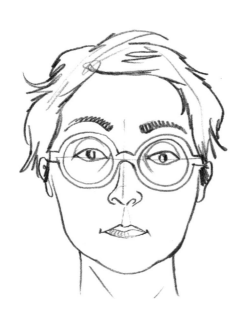

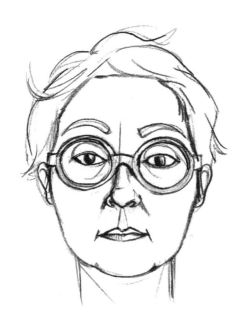

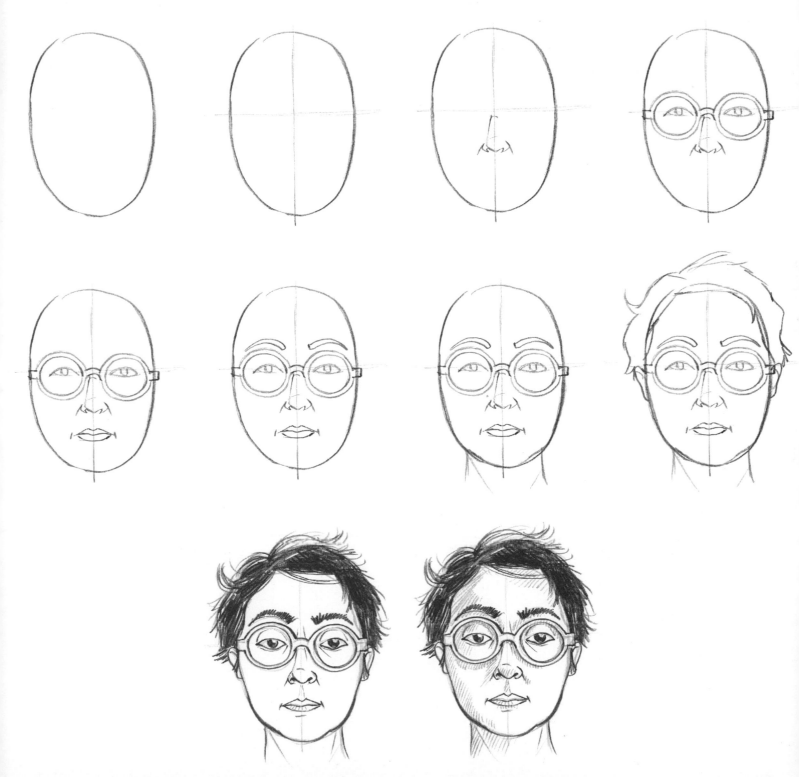

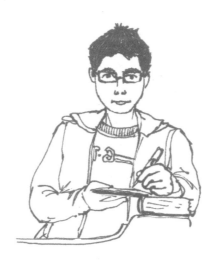

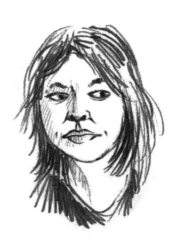

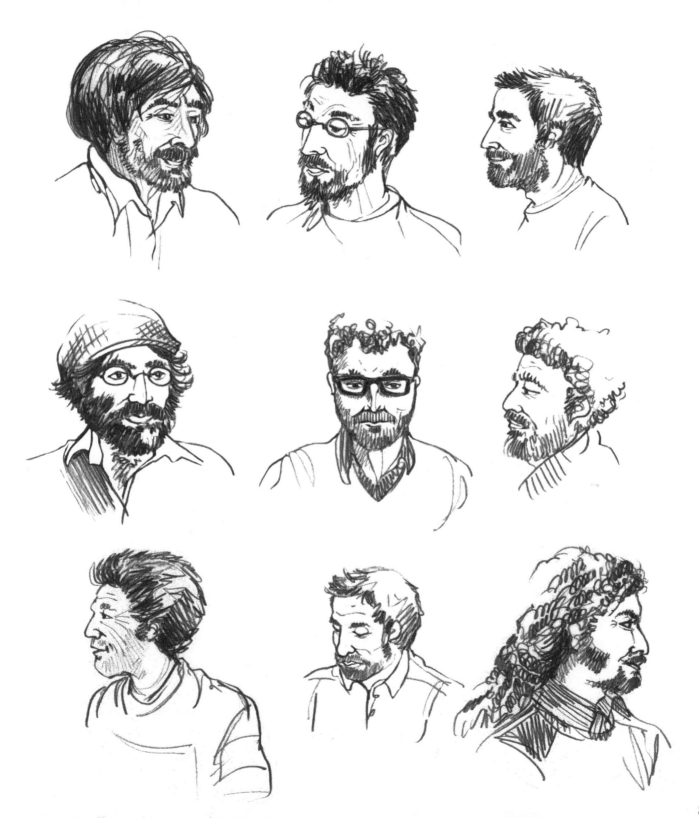

CARICATURES

With a little bit of stylizing, we can create a caricature from the portrait on page 82. To create a caricature, first decide which features you want to exaggerate.

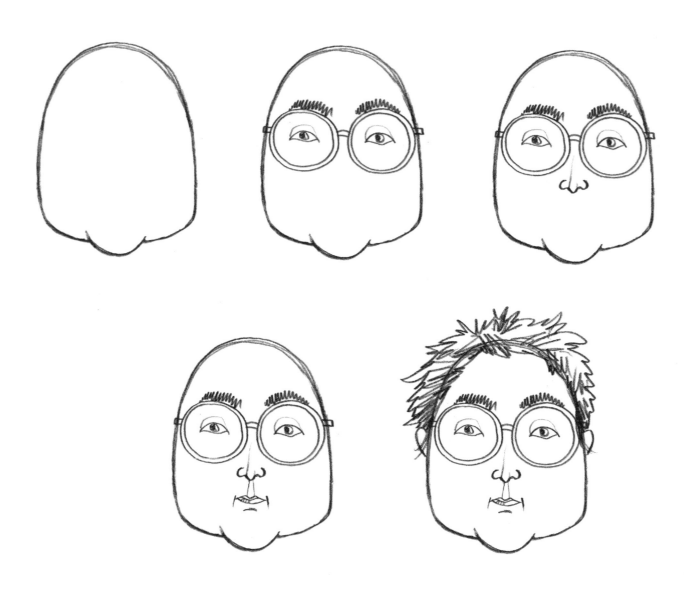

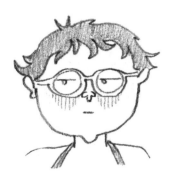

Starting with a face, you can develop a character that will come to life in a story.

By bending the rules that we've discussed so far, you can make up new faces, either imaginary or familiar.

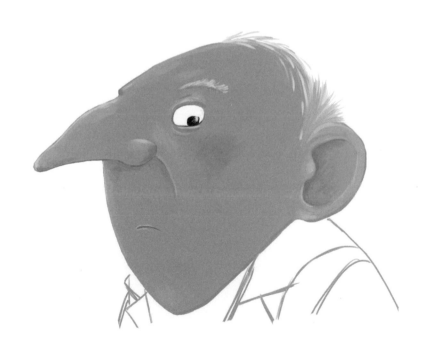

Although they don't move by themselves, plants are alive and flexible. Keep that in mind when drawing greenery. By adding too many lines to a flower, you can make it look too rigid. Too much detail can make a landscape feel unnatural. When drawing living things, let your lines breathe. Keep the strokes light and don't fill in every detail. Leave some blank spaces and play with the lighting. Often in a landscape, a single detail will catch our attention. These details help create a dynamic overall picture that tell a story.

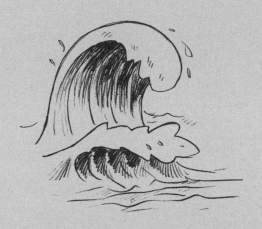

Drawing Nature

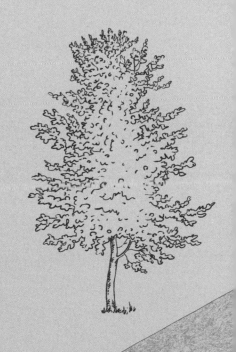

TREES

It's the little details that determine what type of tree you're drawing. Leave blank spaces to show movement and life. A light drawing suggests that the tree can grow and move with the wind. To really bring your tree to life, add highlights and shadows to show the direction of the sunlight and where it shines on the tree.

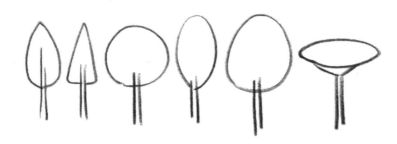

Start by choosing a general tree shape.

Draw a simple shape for the foliage.

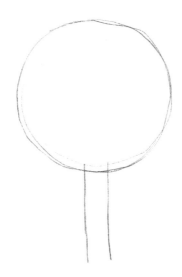

Then add the trunk.

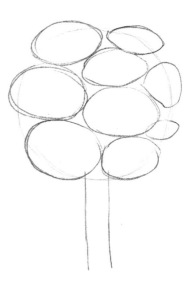

Add some dimension to the foliage.

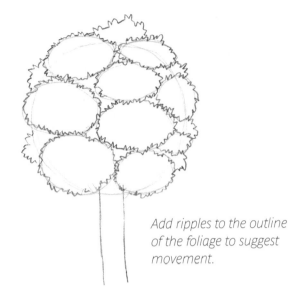

Add ripples to the outline of the foliage to suggest movement.

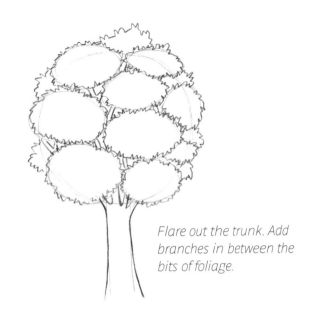

Flare out the trunk. Add branches in between the bits of foliage.

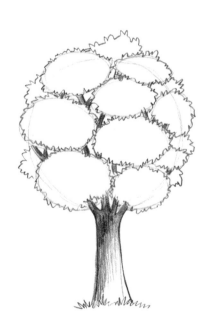

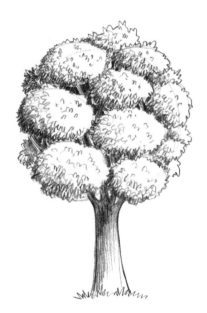

Add shadows. Think about (or look closely if you're drawing from life) where the light is coming from. The shadow will be on the opposite side of the tree. The depth of the shadow on the foliage depends on the density of the leaves. Leave some areas blank to suggest light.

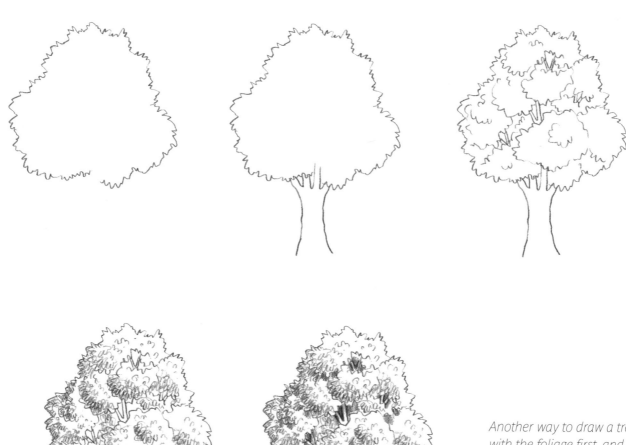

Another way to draw a tree is to start with the foliage first, and then add the trunk and branches. Shade and create depth last.

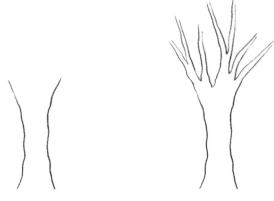

A third method is to start with the trunk, and then add the branches. Add the larger branches first, and then the thinner, secondary ones. Draw the foliage bit by bit, as though you are attaching the leaves to the branches. Complete the tree with some shading.

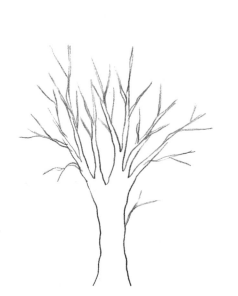

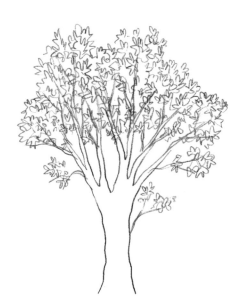

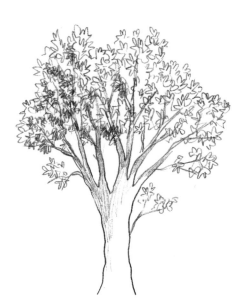

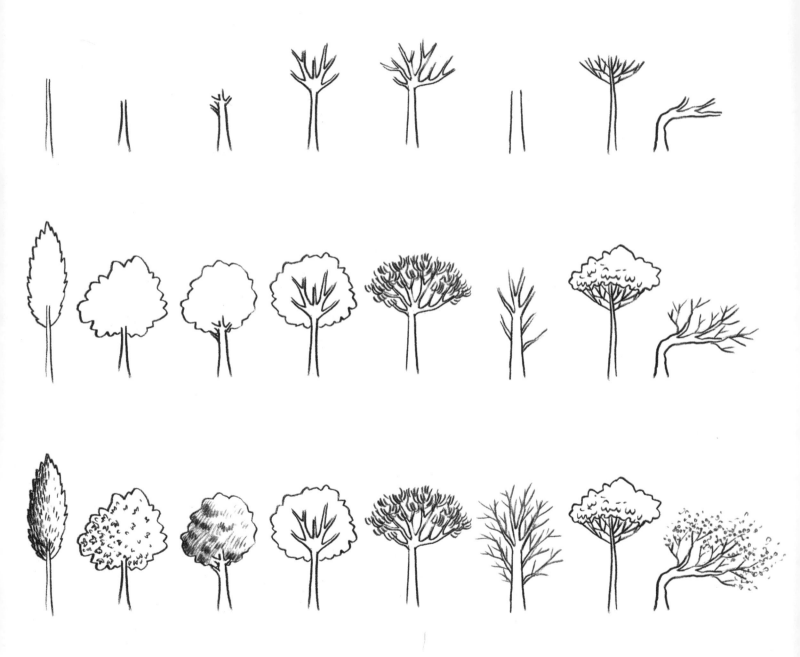

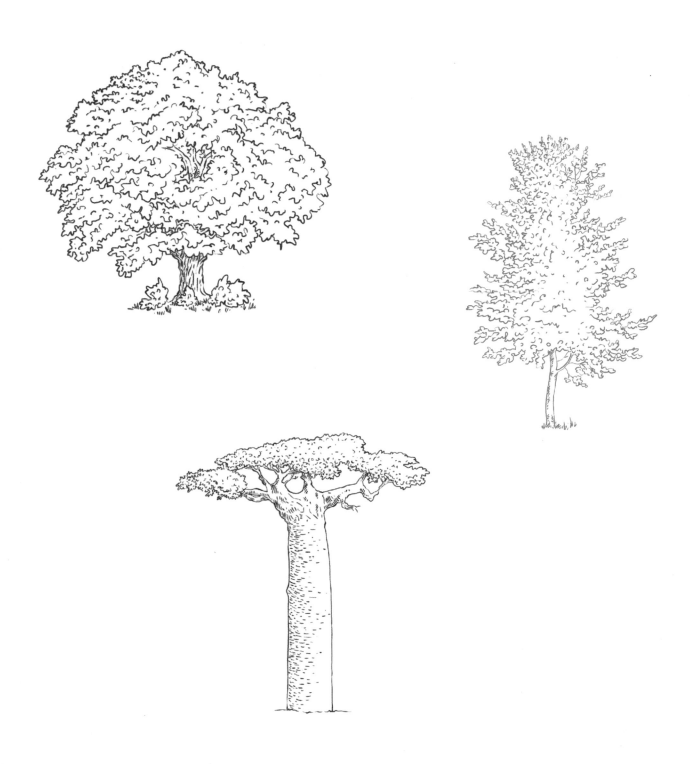

To draw a palm tree, start with the slightly curved trunk. Draw small crosses on the trunk to represent its scaled texture. Then draw long, curvy lines for the palm leaves in the shape of your choice.

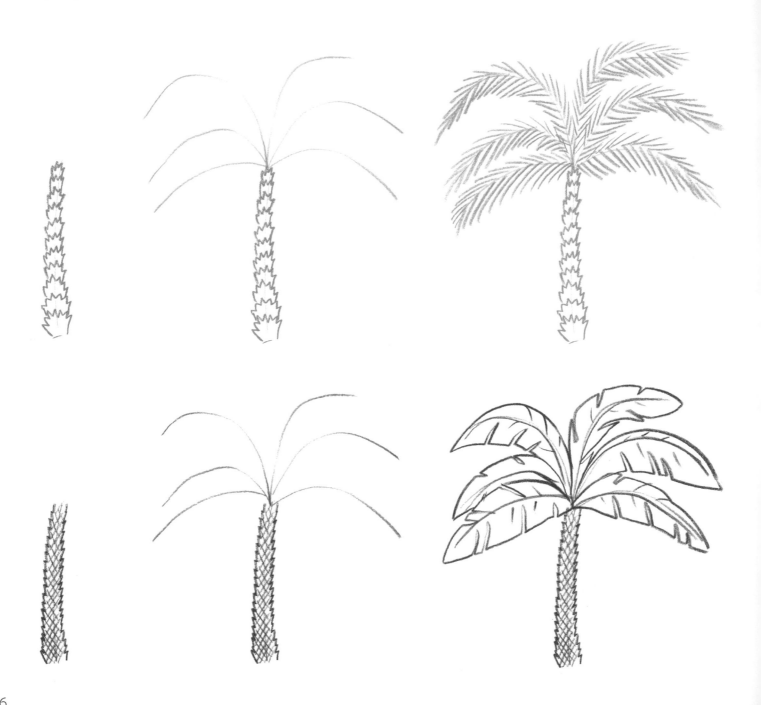

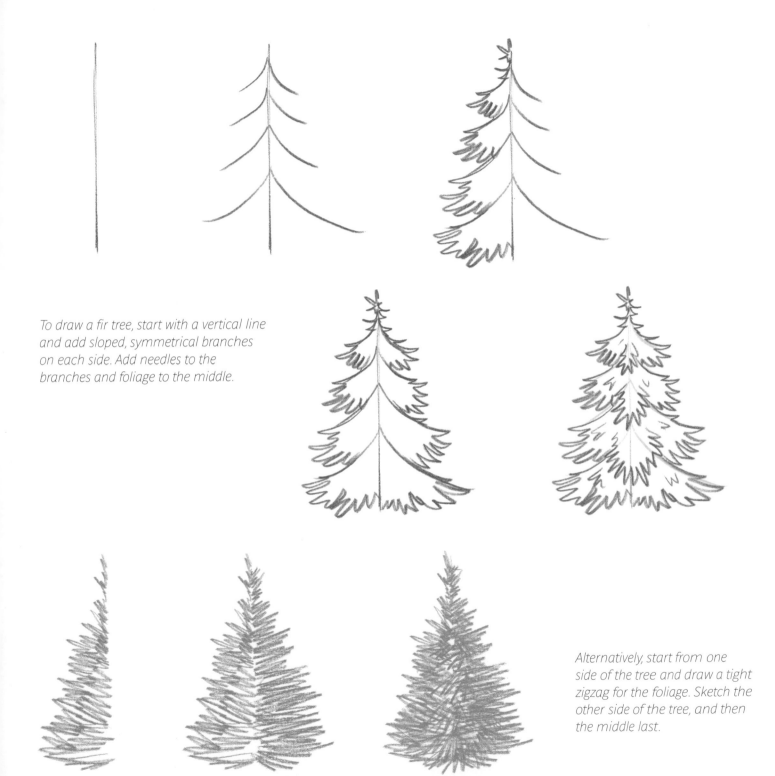

To draw a fir tree, start with a vertical line and add sloped, symmetrical branches on each side. Add needles to the branches and foliage to the middle.

Alternatively, start from one side of the tree and draw a tight zigzag for the foliage. Sketch the other side of the tree, and then the middle last.

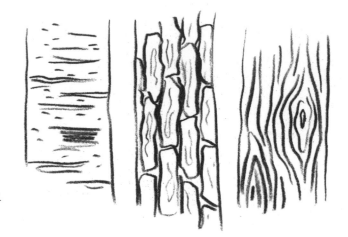

There are many varieties of bark.

To draw a leaf, start with the stem.
Then draw the outline, and then the
veins inside.

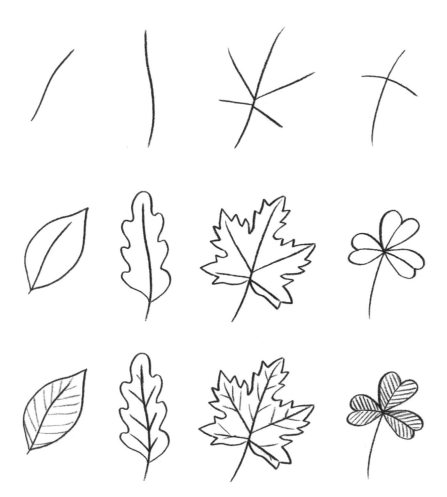

TECHNICAL FOCUS

To add depth to your drawing, focus on the foreground details. Add fewer details as you progress to the background, until the lines disappear on the page. For example, if all the branches of this tree were drawn with the same amount of detail, everything would be on the same visual level, making it look flat and less visually interesting.

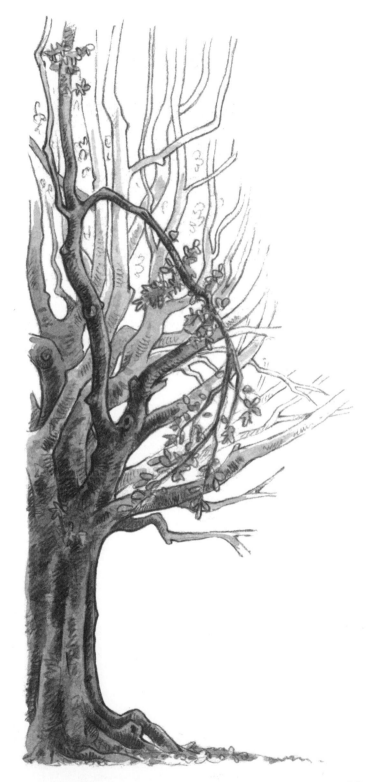

FLOWERS

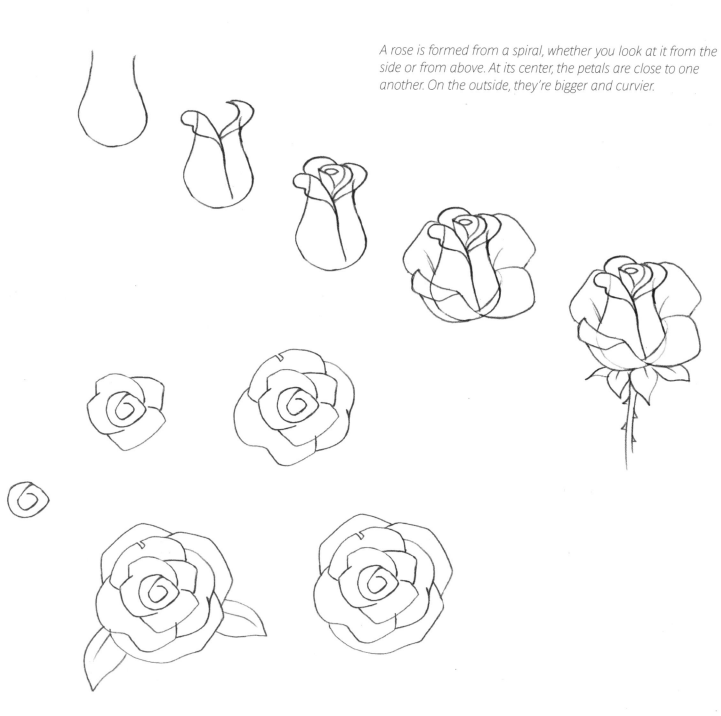

A rose is formed from a spiral, whether you look at it from the side or from above. At its center, the petals are close to one another. On the outside, they're bigger and curvier.

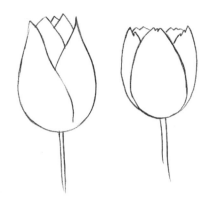

A tulip has large, cup-shaped petals.

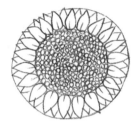
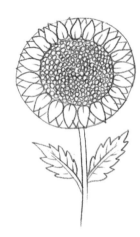

A sunflower is built around a circle. Petals overlap over several rows.

Lily of the valley has staggered rows of small, white bells hanging on both sides of a slightly curved stem.

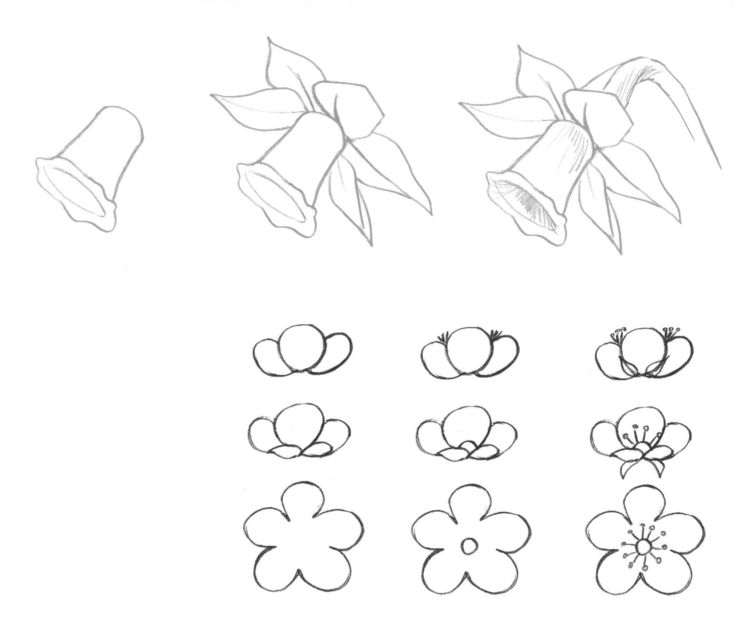
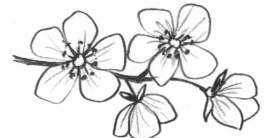

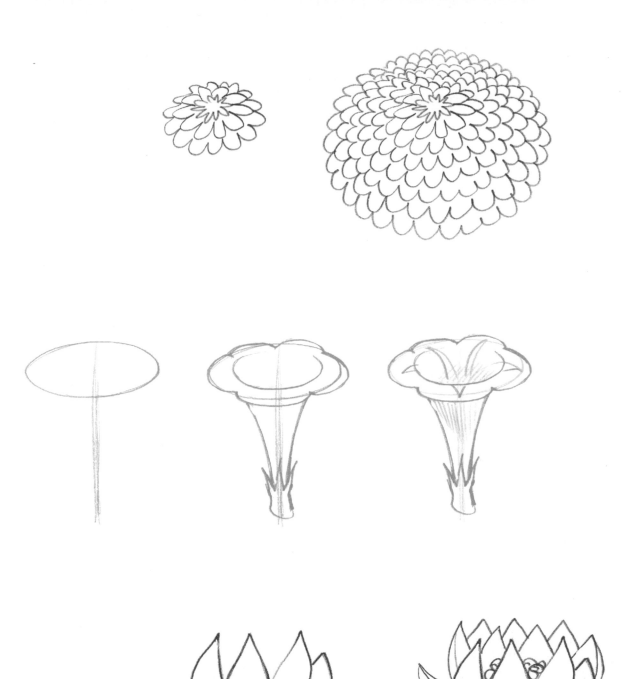

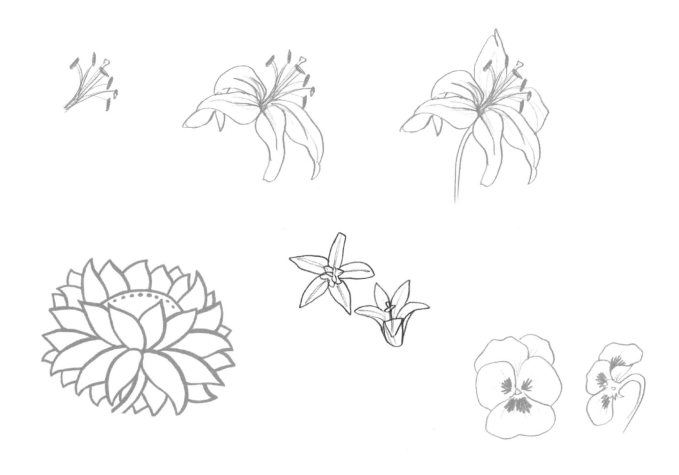

To draw a flower, start with its general shape. Alternatively, you can draw one part, such as the pistil or the heart, and then develop your drawing from there.

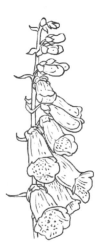

STYLIZING

Flowers can add decoration to your drawings. Add
them to furniture, stained glass, fabric, and wallpaper.

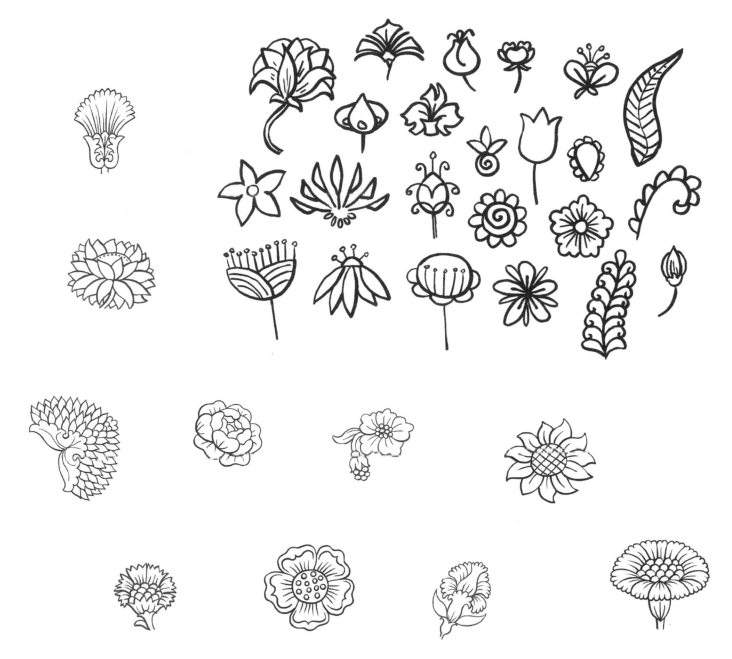

SHRUBBERY

To draw shrubbery, start either with the flowers or
the shape of the bush. When you draw a group
of flowers, such as a bouquet or an arrangement
of flower beds, start with the foreground, and
then develop it as you go along by adding the
background.

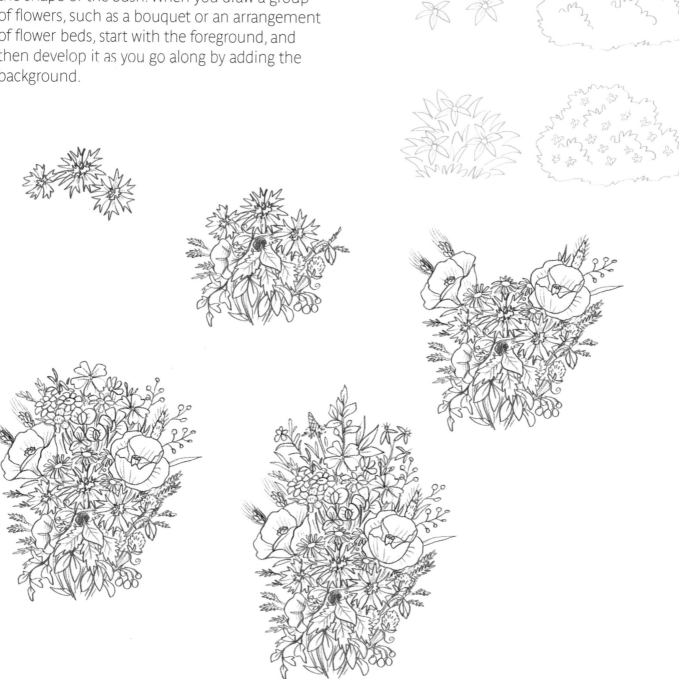

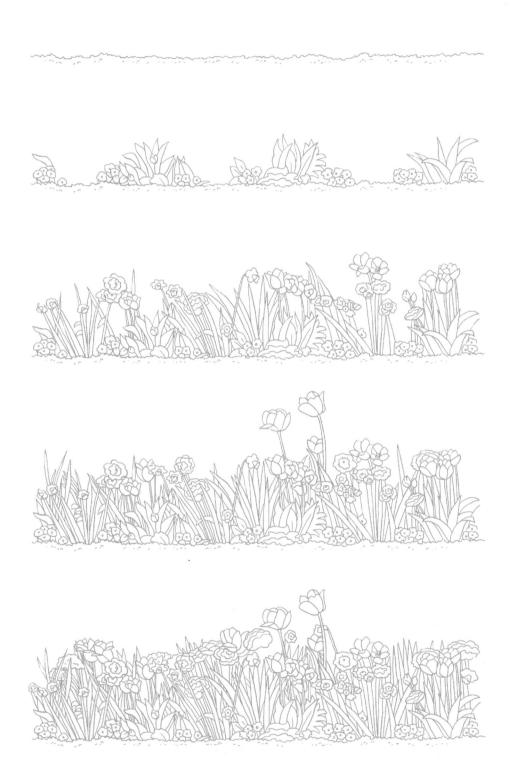

WATER

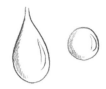

To create a realistic water droplet, shade lightly to add dimension and include a reflection.

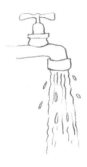

To show that water is running and splattering, add small drops around the main water stream.

The straight lines of a cascade indicate that the water is falling rapidly. This fall creates a cloud of foam. Darken the reflection by drawing small waves on the water surface.

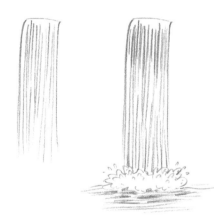

If a cascade is shaped like a flight of stairs, include vertical shadows to show how the perspective is affected by the light.

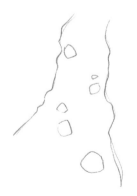

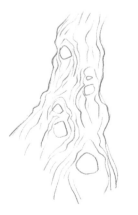

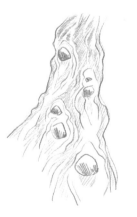

To draw a stream, start with the outline and the stones. Then draw the water path around the stones, and the outline of the bed. Then add shading.

To add perspective to a wave, only shade the underside, not the top or the bumps and ridges.

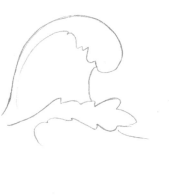 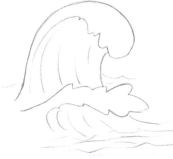 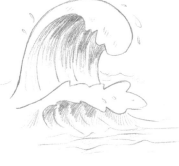

 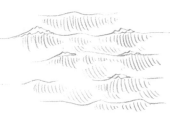 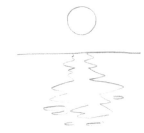 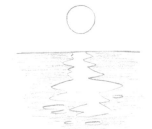

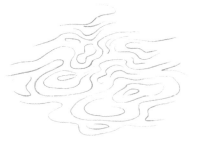

Even when it's calm, the sea is always moving. Thus, the reflection of the sun is also moving.

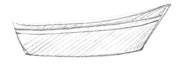 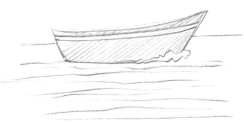 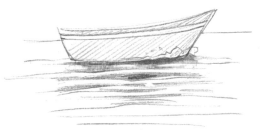

A boat creates foam at its bow where it cuts through the water. Hatching darkens the waves underneath the boat to create a reflection.

 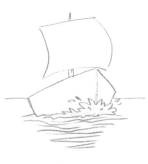

109

LANDSCAPES

To draw a landscape, start by sketching the simple shapes first, such as hills or the horizon. Once you have established the background, place the other elements, including trees, stones, buildings, animals, and people. Always start with a simple, broad outline, and then create more detail. Go over your drawing again, adding more details and more precise lines.

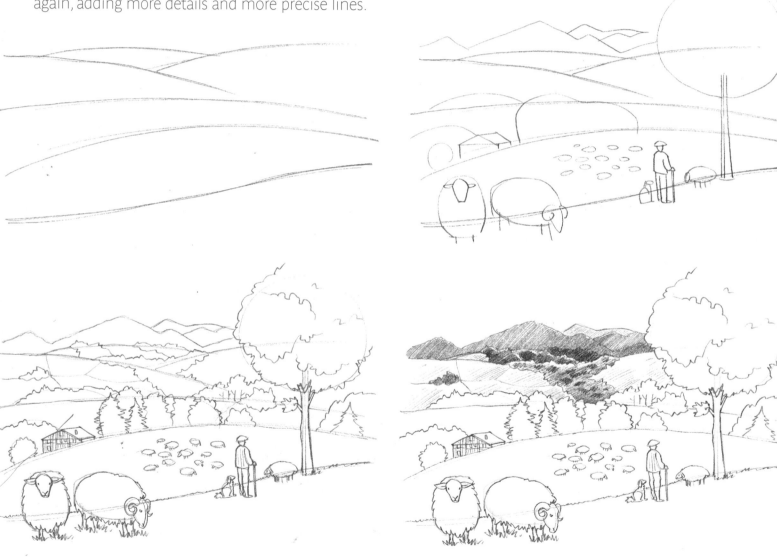

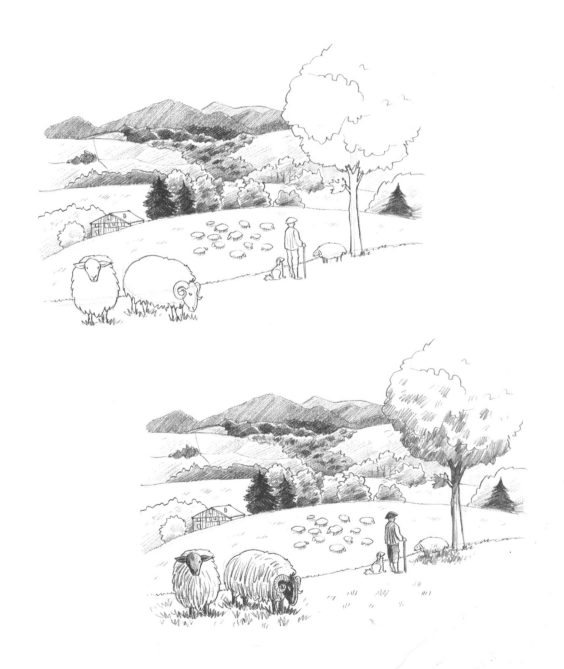

Before shading, erase any visible sketch lines to clean up your drawing, and then add details. Focus the details on the foreground to add depth to your piece.

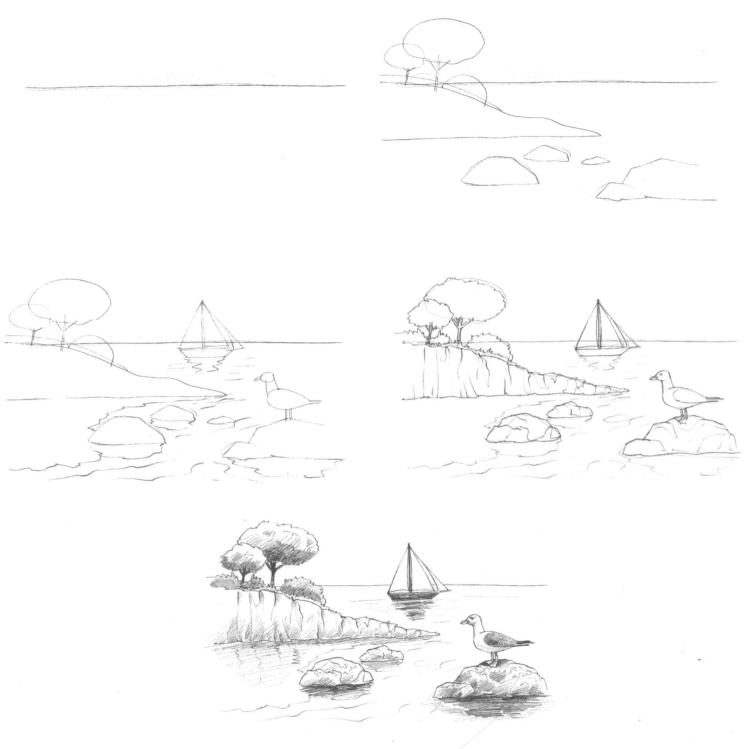

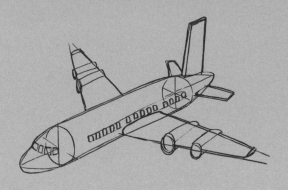

Even a subject that looks complex can be drawn from simple, basic shapes. The three basic geometrical shapes are square, triangle, and circle. The three-dimensional equivalents are cube, pyramid, and sphere. Any other shape is a mix of the three. Begin a drawing by using one of the basic shapes, or join shapes together to create something more complex.

It can be challenging to create an object that has depth. This is where perspective drawing comes in handy. A good rule to remember is that a subject that is close to you always appears bigger than what's in the background.

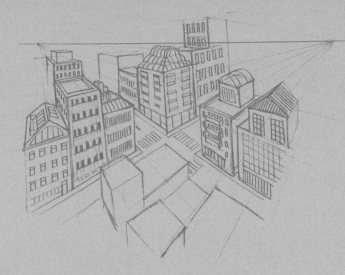

Drawing
Static
Subjects

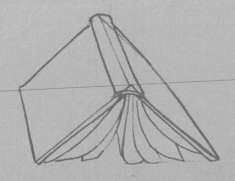

FROM THE SQUARE TO THE CUBE

A square is built from two parallel lines—one vertical and one horizontal—that meet each other. This shape helps you draw anything that has straight lines and right angles.

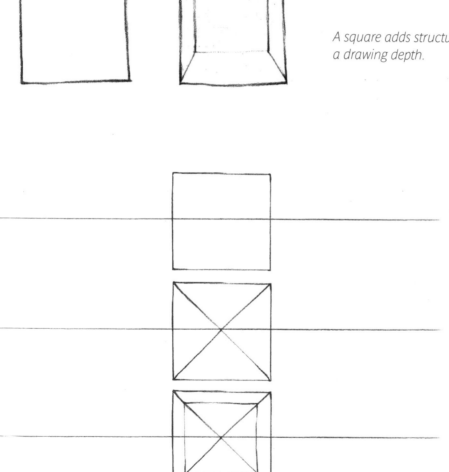

A square adds structure to a drawing; a cube gives a drawing depth.

To draw a transparent cube head-on, draw a square and add a horizontal line though its center. Draw angled lines from each corner to the opposite side. Where the lines meet is called the vanishing point. Then draw a smaller square within the larger square, with its corners on the angled lines.

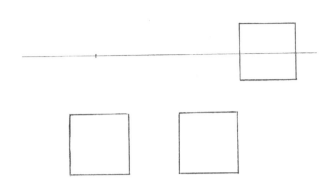

The horizon is set at eye level. On the horizon are vanishing points. Everything between you and the horizon grows smaller as it vanishes toward these points. When you draw in 3D, you are using perspective without even realizing it.

To draw a square from above, or off-center, or from the side, start by drawing the horizon line and the vanishing point. Then place the first square underneath the horizon line, the second square next to it, and the third square on the horizon line, but away from the vanishing point.

Join the corners of each square to the vanishing point. Some lines will be invisible, hidden by the first square.

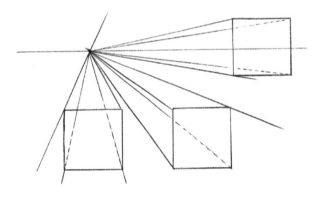

Lastly, draw another square behind each of the squares to create your cubes. All of the corners must be placed on the angled lines, called convergence lines. When they're between the squares, those lines become the sides of the cubes.

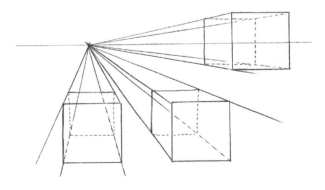

117

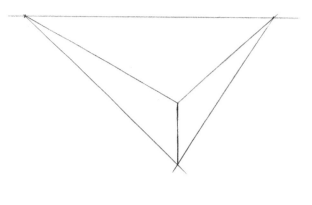

To draw a cube from a three-quarter view, you'll need two vanishing points. Start by drawing the horizon, and then add two vanishing points somewhere to this line. Draw the vertical edge of your cube under and between those two points. Then join the top and the bottom of this edge to the vanishing points.

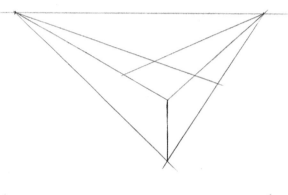

To make the surface of the cube visible, draw lines starting from the vanishing points and crossing behind the edge.

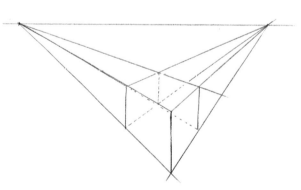

Those lines meet the first convergence lines, which marks the starting point of new vertical lines, or the sides of the cube.

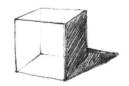

Add a shadow to one side of the cube and an angular shadow on the ground.

TECHNICAL FOCUS

It isn't always necessary to start with a horizon line and vanishing point when drawing a three-dimensional object. With practice, you'll begin to see the invisible lines and points that run behind your drawing. Here are a few examples of objects that take on the basic cube shape.

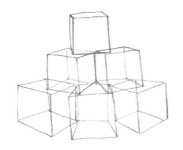

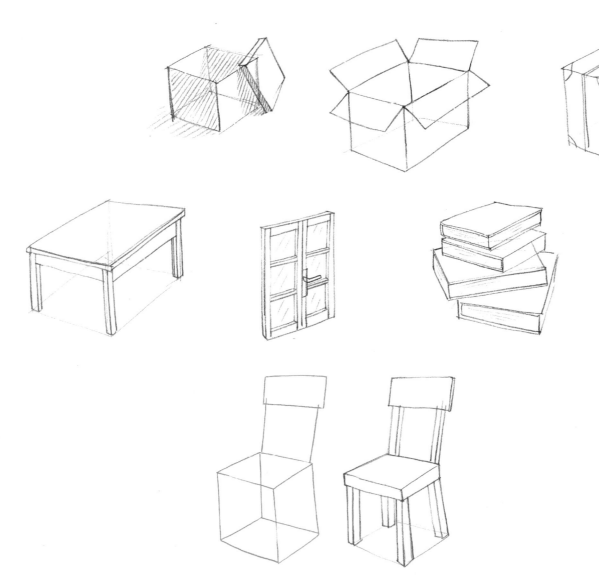

FROM THE TRIANGLE TO THE PYRAMID

A triangle consists of straight lines. It's a useful shape for drawing anything that includes an incline.

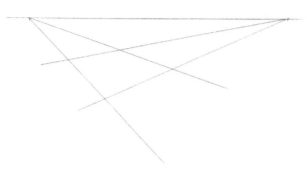

To draw a pyramid, start with a square base. Join the corners of the square to make a point in the middle.

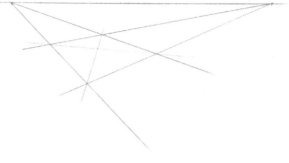

In this square, draw crossing lines from opposite corners to obtain a point in the middle.

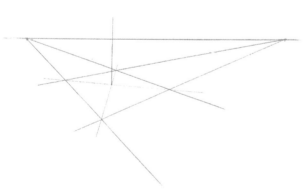

From this point, draw a vertical line.

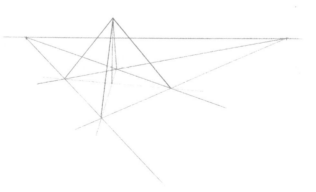

Finish by joining the top of this vertical line with the corners of the square.

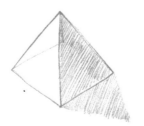

Draw a pointy shadow for the pyramid.

TECHNICAL FOCUS

There are triangle and pyramid shapes in many everyday objects. You can turn a pyramid into a bell tower, or form a roof with two triangles.

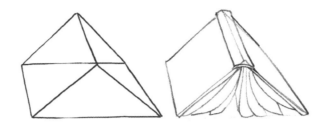

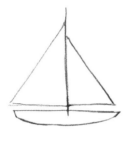

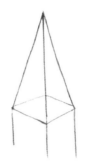

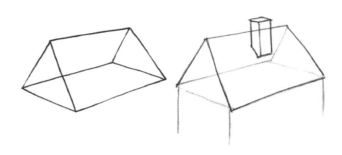

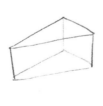

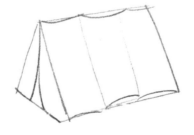

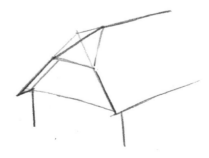

FROM THE CIRCLE TO THE SPHERE

A circle is a round shape without angles. You can stretch it into an oval or deform it into a potato shape.

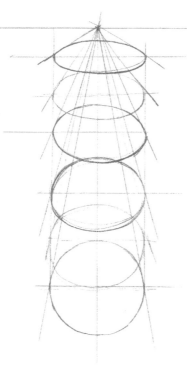

It can be challenging to draw a circle in perspective because there are no angles to help you draw convergence lines. Notice that the closer the circle is to you, the larger it will appear. The closer the circle is to the horizon (at eye level), the flatter it will look.

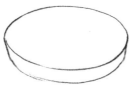

A disk is a thick circle made of two circles with a space in between.

A sphere is full of invisible circles turning on an axis in its middle.

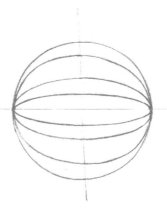

Because there's no angle, the shadow covers part of the sphere. The projected shadow is curved and oval. By shading a sphere, you give it depth.

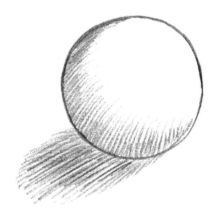

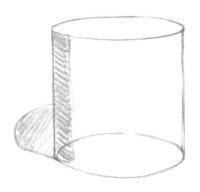

A cylinder consists of two circles, one at the top and one at the bottom, with straight lines forming the sides.

A circle sits at the base of a cone. It becomes a 3D cone when you add two slanted lines to form a triangle.

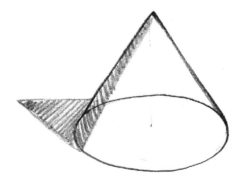

TECHNICAL FOCUS

Spheres and cylinders originate from circles. Try to spot these shapes in the objects around you.

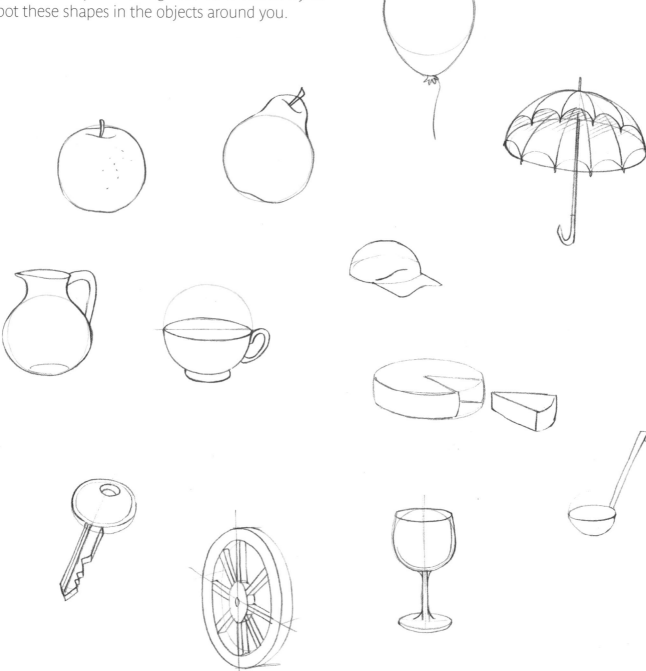

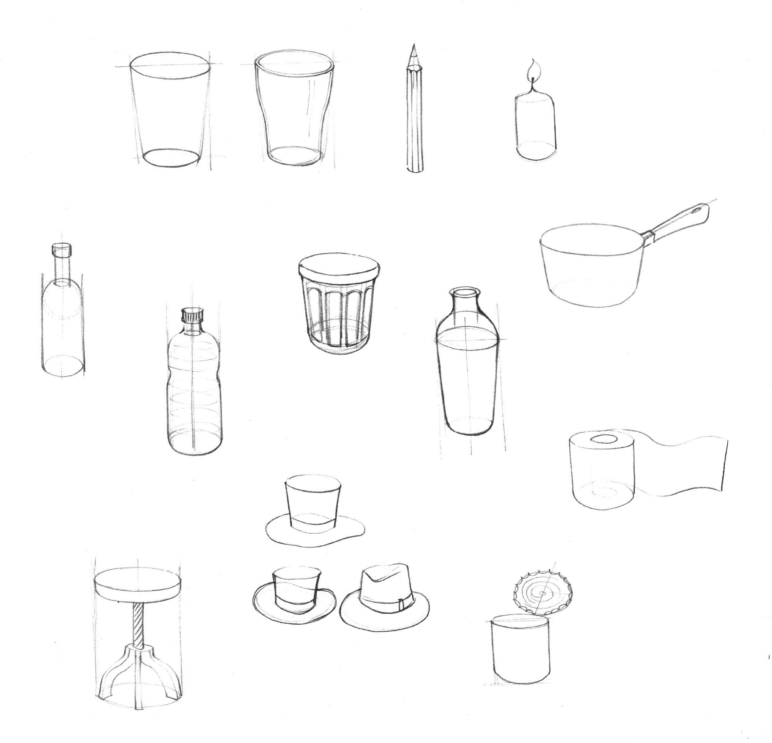

MIXING SHAPES

You can use several basic shapes to create more complex objects.

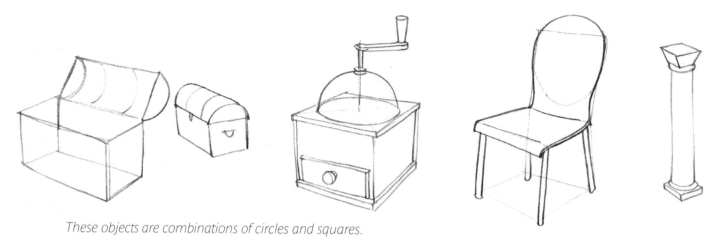

These objects are combinations of circles and squares.

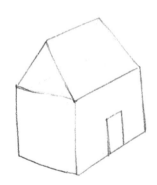

A house is a combination of squares and rectangles.

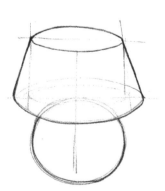

Here you see combinations of triangles and circles.

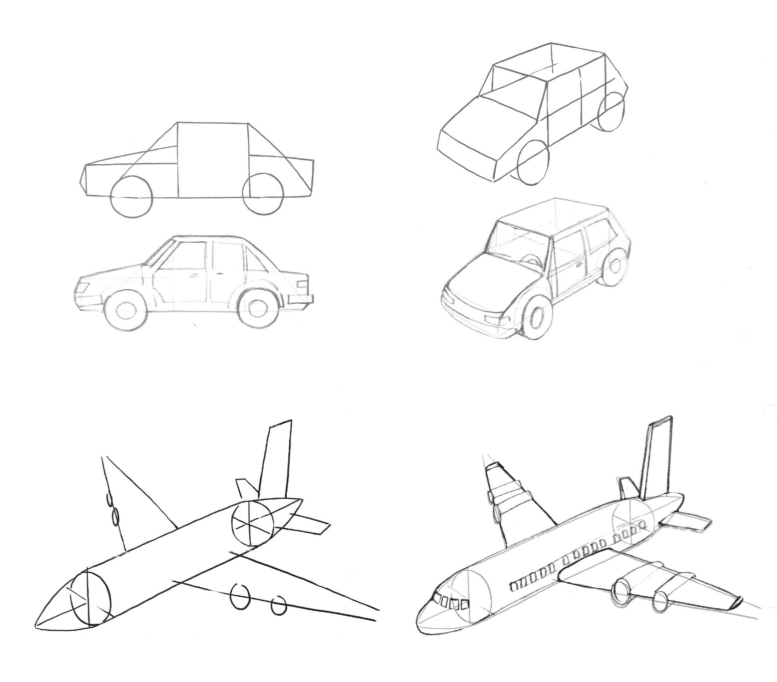

COMPOSITION

From simple, basic shapes, you can create a group of objects. Each element must respect the laws of perspective, as must the composition as a whole. The objects in the foreground will appear bigger than the ones in the background. Background objects might also be partly hidden by the object in the foreground.

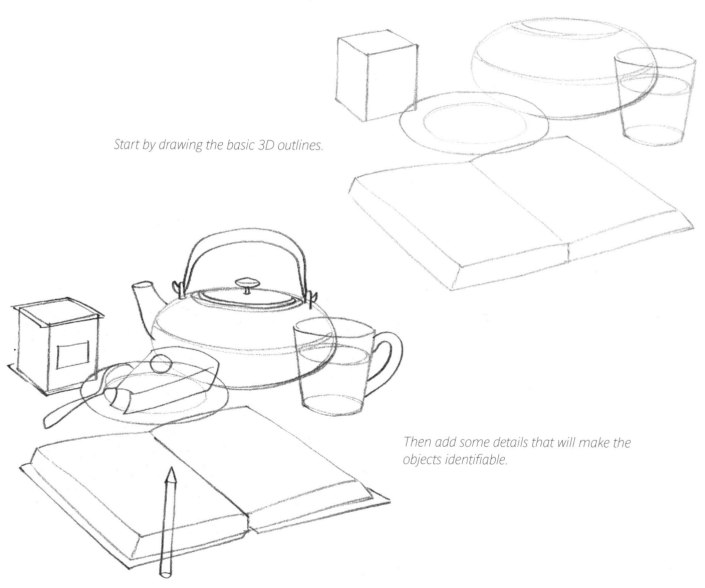

Start by drawing the basic 3D outlines.

Then add some details that will make the objects identifiable.

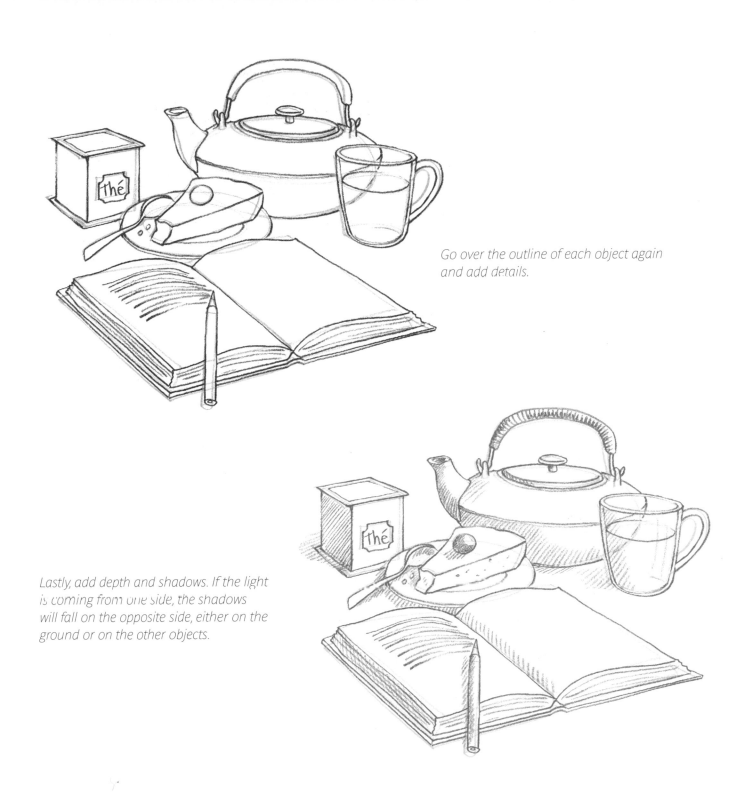

Go over the outline of each object again and add details.

Lastly, add depth and shadows. If the light is coming from one side, the shadows will fall on the opposite side, either on the ground or on the other objects.

BASIC PERSPECTIVE

Beginning a drawing with perspective lines will help you develop an instinctive sense for perspective later on. To train yourself to notice perspective, try a simple exercise. Draw your surroundings as simple 3D shapes without the help of perspective lines. Now imagine where the horizon and convergence lines would be in your drawings.

As you compose your drawing and position your objects, imagine that all of the elements of your drawing are transparent. Include the background lines in your drawing, and highlight the objects in the foreground. This helps you check the perspective and compare each object's size to the other elements in the drawing.

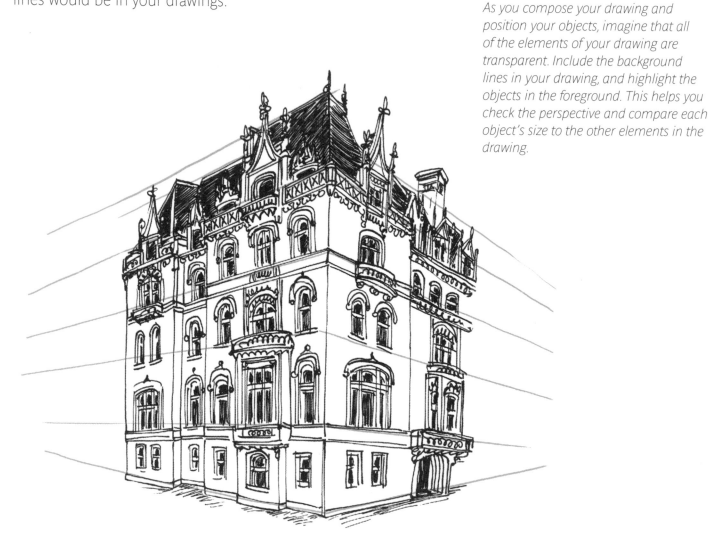

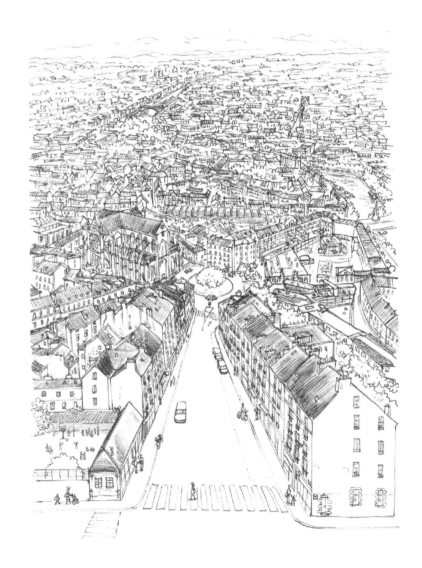

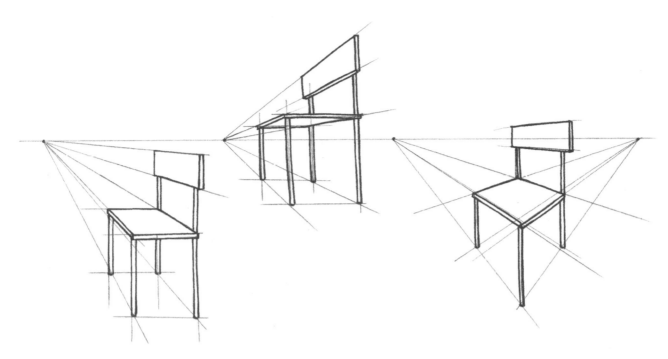

With our knowledge about the cube, we can draw a chair in perspective. When there's only one vanishing point, the horizontal lines are parallel to the horizon. The vertical lines are perpendicular to the horizon.

With two vanishing points, the lines that were horizontal now follow the convergent ones. The vertical lines are perpendicular to the horizon.

Once you understand perspective, you can draw a chair from various angles without drawing the horizon or vanishing points. Simply imagine your horizontal lines vanishing into the invisible horizon.

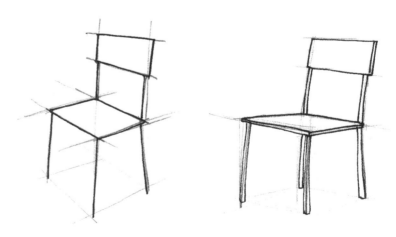

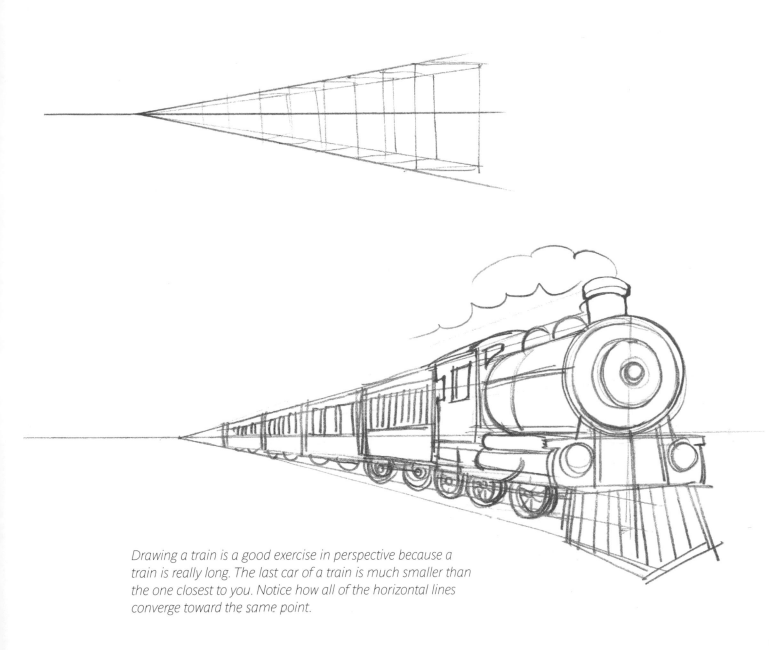

Drawing a train is a good exercise in perspective because a train is really long. The last car of a train is much smaller than the one closest to you. Notice how all of the horizontal lines converge toward the same point.

STAIRS IN PERSPECTIVE

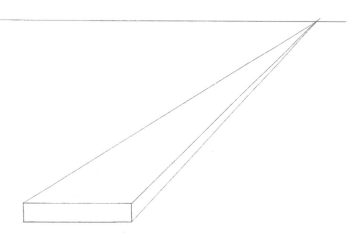

Starting from a vanishing point on the horizon, draw lines to form the first step. Make the horizontal lines parallel to the horizon. Decide on the height and the depth of the step, then draw short vertical lines on the side for the height. The second step is slightly behind on the convergence lines.

Now create lines that run through the bottom of the first and second step toward the top. These lines will give you the staircase's incline. The whole staircase depends on the height and depth of the first step. This is something to decide before you start drawing.

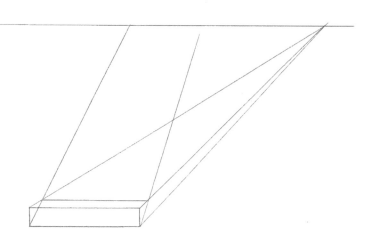

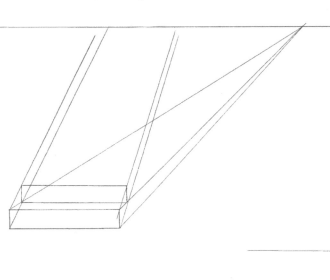

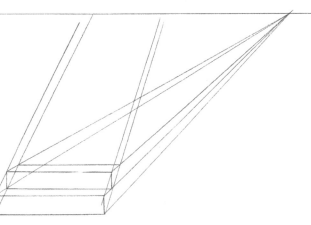

Draw new convergence lines, one after the other, to form each step.

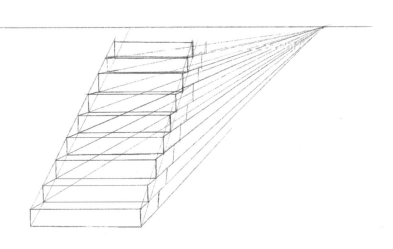

CENTERED PERSPECTIVE

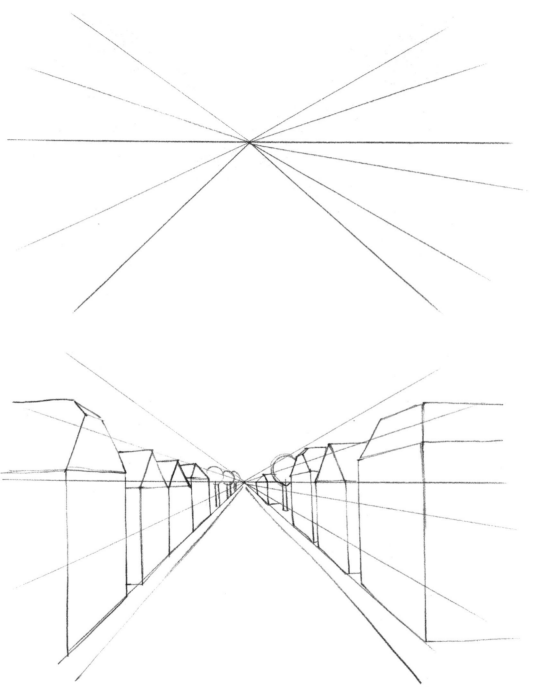

To create a centered perspective, imagine yourself in the middle of the scene you want to draw. The horizon should be at the halfway point between the upper and lower parts of your drawing, with the vanishing point in the center. Convergence lines are split symmetrically on each side.

Place the various elements of your drawing on this set of convergence lines. There's only one vanishing point, so the horizontal lines close to you are parallel to the horizon. The vertical lines are still perpendicular. All other lines are orientated toward the vanishing point.

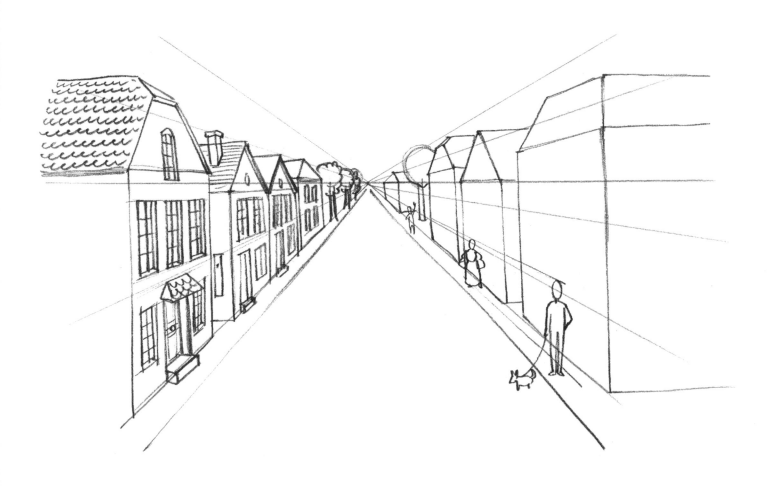

Lastly, add details to these 3D shapes, always following the convergence lines. If you add people to this landscape, they'll also need to be in perspective. The characters in the foreground should be bigger than the ones behind them.

PERSPECTIVE WITH THREE VANISHING POINTS

To draw a checkered floor in perspective, start with the horizon line with a vanishing point in the middle. On each side, and at equal distance from this first point, place two more vanishing points. Now draw a second line parallel to the horizon line. It doesn't matter how far this line is from the first line. On the second line, place a few equidistant marks in order to visualize the distances.

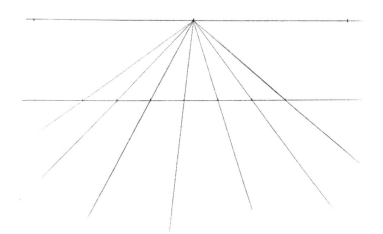

Draw lines from the first central vanishing point to these marks.

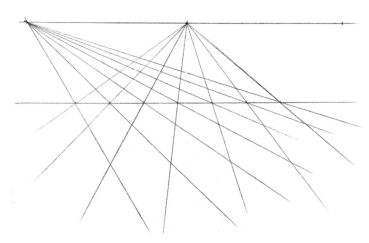

Do the same thing from the two other vanishing points. You'll get something that looks a bit like a spider web.

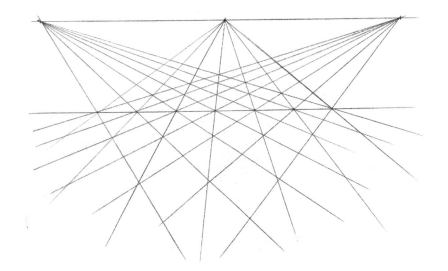

Finally, draw some horizontal lines parallel to the first couple of lines. Make sure those lines and the convergence lines meet where the latter cross each other.

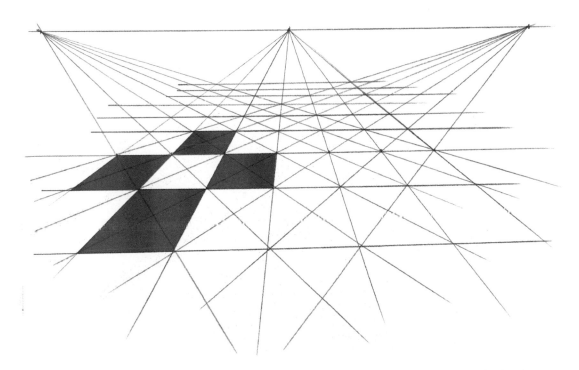

The squares at the front of the checkered floor are much larger than those at the back. Perspective is very apparent here.

VIEW FROM ABOVE

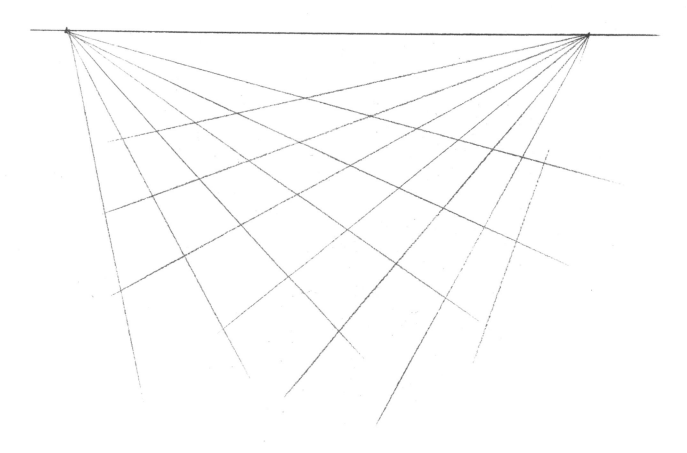

*To draw a city from above, draw several convergence lines
originating from two vanishing points.*

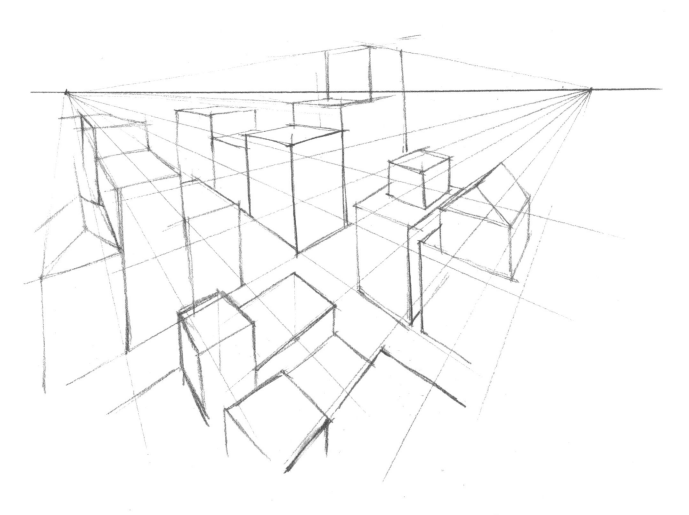

Place the buildings where the lines meet. Make sure any vertical lines are perpendicular to the horizon line if you want your buildings to stand straight.

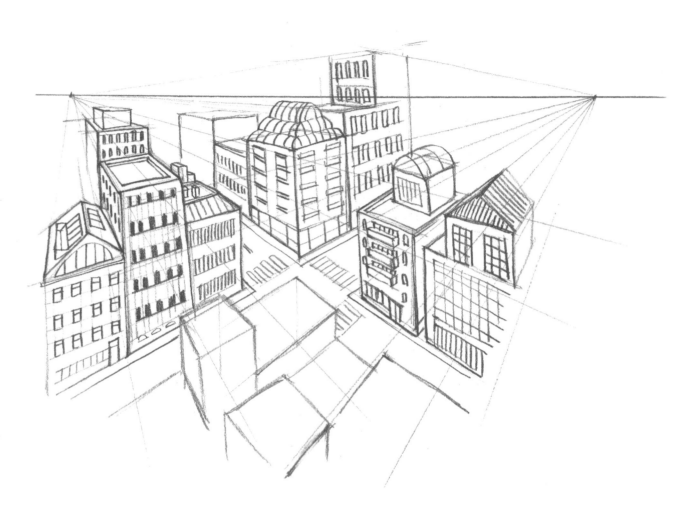

Add as many details as you want. You can even draw some buildings
above the horizon line. Add more convergence lines as you go to help
you expand your city.

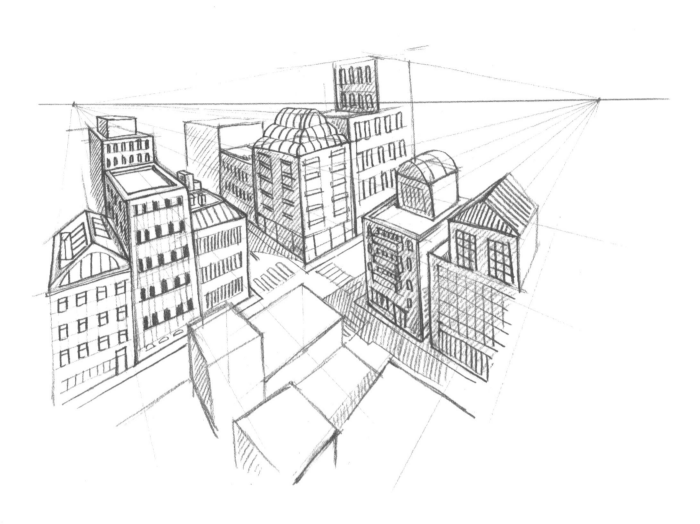

Add shadows to really bring your city to life.

VIEW FROM BELOW

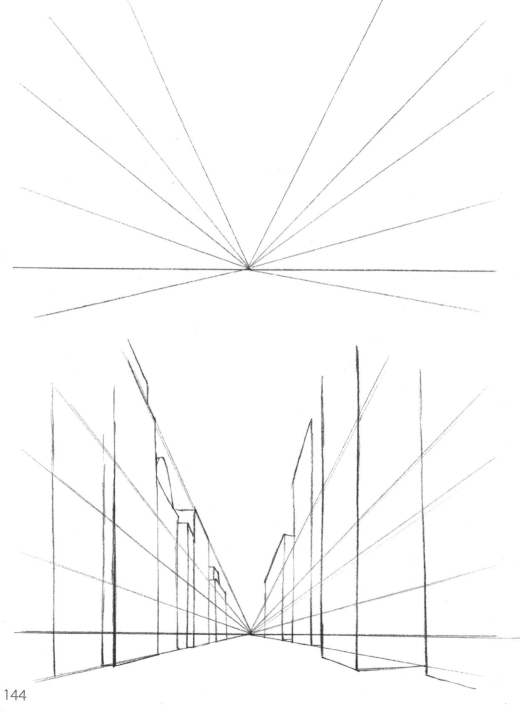

To draw a cityscape from the viewpoint of standing in the middle of a street, start with a centered perspective with one vanishing point. Draw convergence lines that go upward, with the exception of two lines on the ground that dip below the horizon.

Start the tallest buildings on the two lines below the horizon. Make sure the vertical lines are perpendicular to the horizon.

144

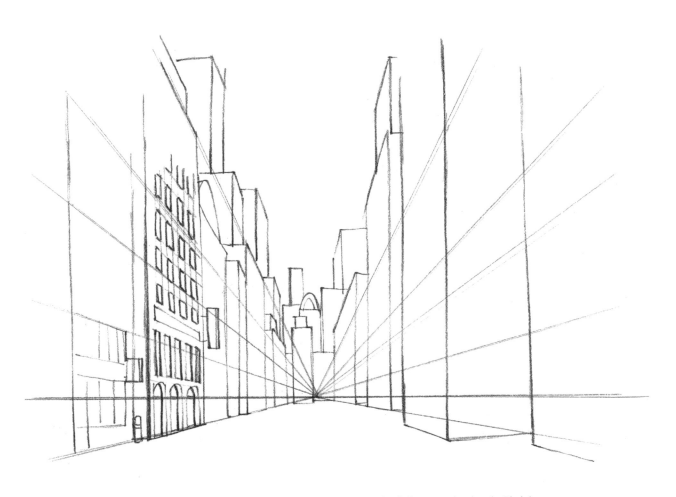

Place a few buildings on the horizon line and add some buildings at the back. Finish by adding details.

INTERIORS

To draw a room, start with a rectangle.

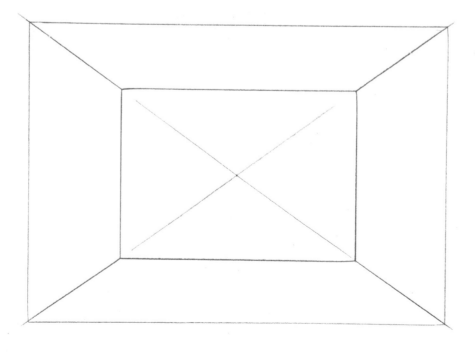

Draw two lines starting in each corner that cross in the middle. Where they meet is your vanishing point. Draw a second, smaller rectangle inside the first one with its corners on the convergence lines. This will represent the back wall of the room. The convergence lines between the two rectangles mark the walls, the floor, and the ceiling.

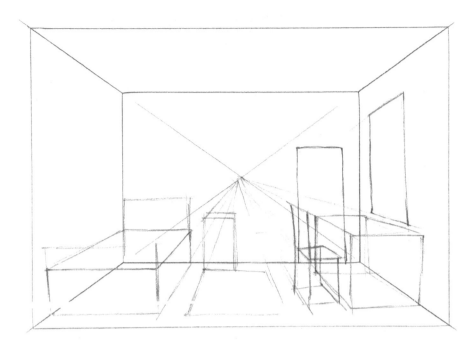

Add convergence lines to place various elements in the room, including furniture, a rug, a door, and a window. The horizontal and vertical lines are parallel to the sides of the rectangle.

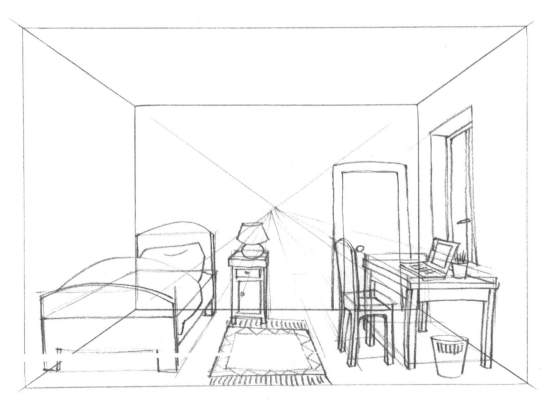

Lastly, add more detail.

Now that you know the secret to drawing shapes, proportions, and dimensions, you are ready to draw the world—or reinvent it. Remember: The more you draw, the more confident you'll feel when drawing. To help you develop your skills, carry a sketchbook with you wherever you go. Some days, you'll have time to accomplish a drawing that requires several steps. Other days, you'll just manage a sketch or two. No matter what—keep drawing. This is the key to help you draw every day and make progress.

Taking Flight

THE SKETCHBOOK

A sketchbook is a good tool to help you practice drawing every day. Use it to sketch your surroundings, or to take notes when studying objects or people. You can draw from real life, books, or any other source. When you draw in your sketchbook, you are compiling a visual library that you can use to compose and add detail to your drawings. Drawing in a sketchbook also helps you memorize subjects visually. Then you will be able to draw from your imagination, which helps when you don't have a model or subject to reference.

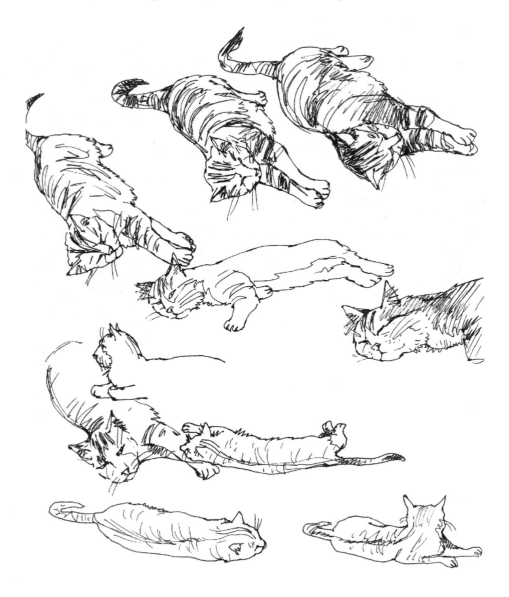

When you study a subject, don't just draw it once— draw it from every angle. By moving around, you'll spot new features and perspectives.

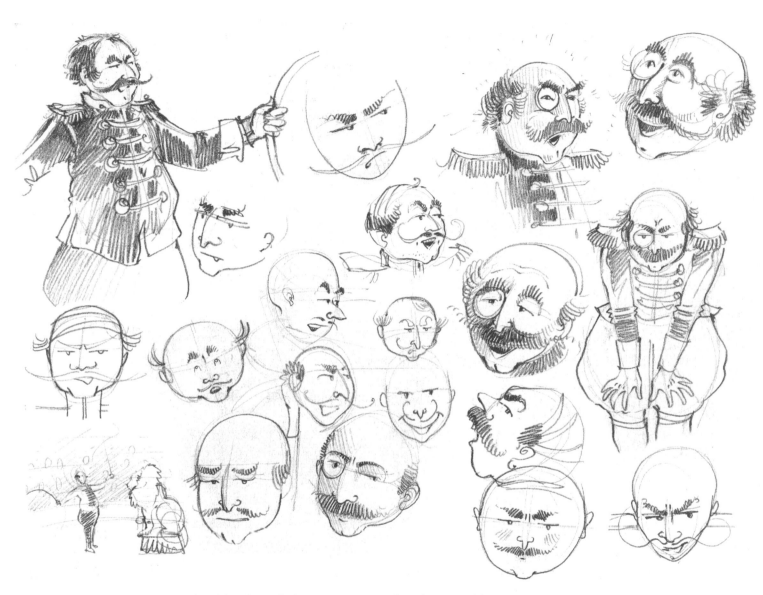

A sketchbook can help you create your imaginary world.
You can invent new characters by scribbling and trying
out different expressions, attitudes, and proportions.

A working sketchbook is full of errors, first-tries, and scribbles. Choose a sketchbook that you feel comfortable experimenting in. If the sketchbook is too fancy or expensive, you might not feel like you can draw freely in it. The best kind of sketchbook is one that allows you to draw easily.

Sketchbooks come with all types of paper, including graph paper. Even if you think you might use ink or paint in your sketches, it's best to choose a sketchbook with paper that isn't too thick.

153

THE TRAVEL BOOK

A travel book is a visual travelogue that includes colored sketches and drawings, sometimes with text and notes. A travel book can tell the story of a journey, or it can be a visual diary of day-to-day activities. Choose a sketchbook size that works for you and your drawing style. A small book is portable and easy to carry. A bigger one will be less portable, but might give you more room to include more drawings. Because you will be telling a story on each page, be mindful of each element on the page. It's easy to start drawing in one corner, and then realize that the framing is too big, or that you didn't leave space for your main subject.

Fill your drawings with color, or just pick a spot or two to highlight. Choosing just a few colors will draw the eye to particular areas.

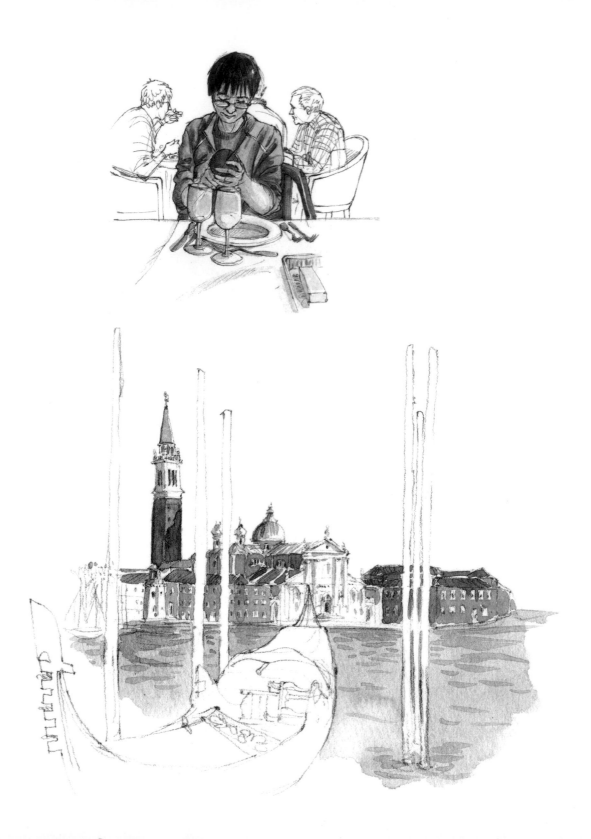

Prè du ponte Rielo

Leave some blank spaces on the pages of your book. Let your drawings breathe!

Your everyday surroundings can also serve as great subjects. Drawing the same places over and over again will help you refine your skills. You don't have to travel to create a fascinating book.

Quarto is the authority on a wide range of topics.
Quarto educates, entertains, and enriches the lives of our readers—
enthusiasts and lovers of hands-on living.
www.quartoknows.com

© 2017 Quarto Publishing Group USA Inc.
Published by Walter Foster Publishing,
an imprint of The Quarto Group
All rights reserved. Walter Foster is a registered trademark.

Translated into English by Marion Serre

The original French edition was published as *Le dessin facile* (ISBN: 978-2-2151-4999-6) by Lise Herzog.
© Fleurus Editions, Paris – 2016

Commissioning Editor: Tatiana Delesalle
Editors: Helene Raviart, Marion Pelle
Drawings: Lize Herzog
Art Director: Julie Pauwels
Design: Vanessa Paris
Production: Gwendoline da Rocha

6 Orchard Road, Suite 100
Lake Forest, CA 92630
quartoknows.com

Visit our blogs at quartoknows.com

Printed in China
1 3 5 7 9 10 8 6 4 2

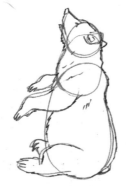